IMAGES
*of America*

# JOLIET

## "An Evening of Celebration"
### Souvenir Program

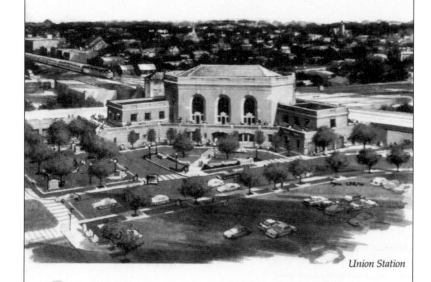

*Union Station*

## Saturday, October 19, 1991
## 6:00 p.m.

*Commemorating the restoration and rededication of Joliet Union Station*

DRAWING OF LANDMARK UNION STATION. Early in the 1900s, railroad trains traveled at street level through Joliet causing catastrophic traffic jams. Through the cooperation of the Chicago and Alton, the Santa Fe, and the Rock Island Lines, and Joliet's leaders, a project to elevate the tracks through downtown creating one grand railway hub was begun. Chicago architect Jarvis Hunt was hired to design the project. Work to raise the tracks began in 1908, and the original station was completed in 1912. (Courtesy of Larry Rossi.)

*On the cover:* Junior Members of St. Francis de Sales Lodge No. 29 K.S.K.J. (Kranjska Slovenska Katolinska Jednota, American Slovenian Catholic Union) around 1936 are pictured during a 40th anniversary celebration. One of five local Joliet lodges, this fraternal life and annuities organization was founded in Joliet on February 2, 1896. (Private collection.)

IMAGES
*of America*

# JOLIET

Marianne Wolf

ARCADIA
PUBLISHING

Published by Arcadia Publishing
Charleston SC, Chicago IL, Portsmouth NH, San Francisco CA

Printed in the United States of America

Library of Congress Catalog Card Number: 2006922319

For all general information contact Arcadia Publishing at:
Telephone 843-853-2070
Fax 843-853-0044
E-mail sales@arcadiapublishing.com
For customer service and orders:
Toll-Free 1-888-313-2665

Visit us on the Internet at http://www.arcadiapublishing.com

To Joe and Cele

# CONTENTS

# LETTER FROM THE
# MAYOR OF JOLIET

Joliet, Illinois . . . the city of steel and stone, located at the crossroads of mid-America. As the mayor of Joliet for 14 years and as a lifelong Joliet resident, I am so proud of the incredible transformations that have occurred in this wonderful city. Growing up on the east side of Joliet in the 1930s, there were about 43,000 people living in Joliet. During my tenure as mayor, Joliet's population rose from 77,000 in 1991 to 134,000 in 2006, making Joliet the tenth fastest growing city in the entire nation!

Joliet is a great place to live, work, and play. The city council and I continue to strive to make Joliet an affordable and safe place for our residents and visitors. We have provided assistance to two very important components of our population . . . our children and our senior citizens. The City of Joliet provides financial assistance to all our schools our children attend, and we have reduced fees for our seniors.

Joliet is so proud to be home to many famous people such as New York Yankee Jesse Barfield, Philadelphia Phillies player Mike Grace, Chicago Bear Tom Thayer, major-league umpire Mark Carlson, actors Audrey Totter and John Barrowman, as well as the sensational singer Lionel Ritchie.

Joliet has become an entertainment destination for people all over the country. The Chicagoland Speedway hosts an annual NASCAR race that is broadcast nationwide, and the Challenge Park Paintball facility hosts tournaments that have brought celebrities to our city. Other amenities that make Joliet so popular are two riverboat casinos, the Route 66 drag strip, the autobahn Country Club where amateurs with expensive cars can race, a minor-league baseball stadium, and of course, the magnificent Rialto Theatre that is considered the "jewel of Joliet."

I hope you enjoy reading this book, and I hope you find pleasure in either living in or visiting the great city of Joliet.

—Mayor Art Schultz

# INTRODUCTION

People have always eyed Joliet's bluffs and prairies and envisioned its possibilities. The fertile area known as the Des Plaines River Valley first impressed explorers Louis Jolliet and Fr. Jacques Marquette in 1673. The same land inspired Charles Reed in the 1830s to build the first log cabin and first form of industry, a dam and a partial mill near the present-day intersection of Bluff and Jefferson Streets—a decision that many say made Reed Joliet's founding father. Settler James McKee would buy out Reed in 1834 and complete and operate the mill until the Illinois and Michigan Canal was constructed.

Joliet was incorporated as a city in June 1852, although the original settlement dates back to 1837, when it was known as the Village of Juliet. As the town shook off its prairie dust, a city rose from mined stone, forged steel, and the sweat of the common man. To learn the story of Joliet is to understand the cultural montage of people who settled there, what drew them to the area, and how they lived and thrived. In the early days, jobs were plentiful and a mélange of languages and races contributed to Joliet's foundation. The Irish arrived, so too German, Slovakian, Slovenian, Polish, Croatian, and Hungarian immigrants in search of a better life. Immigrants and black settlers labored together with picks, shovels, and wheelbarrows to open 96 miles of the Illinois and Michigan Canal by 1848, causing a dramatic change to occur in Joliet.

The canal brought more people, improved commerce, and connected Joliet with the rest of Illinois from the Great Lakes to the Mississippi River. The growth of America's railways in the area would match the waterways, and Joliet would benefit from seven major railroads crisscrossing the town including the Elgin, Joliet and Eastern Railway, the Atchison, Topeka and Santa Fe, the Chicago and Alton, the Michigan Central, and the Rock Island Line. As early as 1900, up to 200 trains a day ran through Joliet.

By 1861, Slovenian immigrant Markus Kraker would come to work as a business entrepreneur of merchandise and notions, shoemaker, and cigar manufacturer before turning his attention to work in a stone quarry until he acquired the necessary funds to purchase the same quarry. Government contracts for local limestone during the mid-1860s and the Great Chicago Fire of 1871 increased the demand for stone from Joliet quarries. By 1890, more than 1,500 men would be employed by the stone companies. Joliet's steel mills prospered and became a chief employer of the city with more than 2,000 workers in 1900.

As Joliet grew it also suffered epidemics in its early years—typhoid fever in 1881, smallpox in 1882. In 1917, local headlines reported "an epidemic of illness and disease worse than any ever experienced in the city." Records from both of Joliet's hospitals, St. Joseph's and Silver Cross noted "both institutions crowded beyond capacity" to combat grippe, pneumonia, whooping cough, and contagious diseases.

If America has been described as the melting pot of the world, the same can be said of Joliet. When the 20th century began, Joliet embraced large numbers of eastern European immigrants. By 1890, the census reported a population of 23,264 and 271 industries employing 3,201 workers. They traveled to what was the largest transportation hub in Illinois outside of Chicago. Here in

the city of "steel and stone," men mined the limestone quarries fulfilling government contracts, defined the Illinois and Michigan Canal, and worked in steel mills, breweries, and manufacturing and railroad yards to forge a community of neighborhoods they could be proud to call their new home. As the industries flourished, the immigrants clustered in ethnic neighborhoods, establishing their own churches, schools, and fraternal organizations.

Few communities in Illinois have seen their population explode twice in a century and remain a great place to build and a great place to live. By 1955, the National Municipal League and *Look Magazine* recognized Joliet as an All-American City. But during the 1970s and 1980s, Joliet suffered from high unemployment and a shift of its central business district. Due in large part to gaming casinos, auto racing, semi-professional baseball, and the resurgence of the downtown area including the landmark Rialto Square Theater used for performing arts, Joliet is now seen as an entertainment destination. Significant recent enhancements for the city included a new branch library at Black and Essington Roads to accommodate the expanding west side and the award-winning Joliet Area Historical Museum in the downtown area. Today this city is recognized by the national press as one of the fastest growing in the United States.

# *One*

# THE NEIGHBORHOODS

Joliet is known as much for its rich wealth of cultures as it is for the stone and steel that first lured the settlers and immigrants to the area. After grueling work days at the mills and yards, the workers went back into their neighborhoods where local businesses catered to their ethnic heritage, preserving their languages, foods, and traditions.

Along with this economic growth, workers yearned to establish their own places of worship and bury their dead in hallowed ground. Cemeteries were among the first plots of land to be set aside for public purposes, and churches were among the first public structures to be built. The Diocese of Joliet dates the area's history of the Catholic Church to 1837, when Irish construction workers on the Illinois and Michigan Canal were visited by Fr. James O'Meara, and the county's first resident priest, Fr. John Plunket, ministered to canal workers during a malaria epidemic.

Second Baptist Church, organized under the spiritual guidance of Rev. T. C. Fleming, was the first black church in Joliet, and a second, Brown Chapel A.M.E. Church, would organize in 1887, according to Hope Rajala's *Black and White Together.*

Other early churches established in Joliet included Christ Episcopal Church (1835), Universalist Society of Joliet (1836, later Universalist Unitarian Church), St. Patrick Catholic Parish (1838), First Lutheran Church (1870), Second Baptist Church (1879), and Bethlehem Lutheran Church (1880).

Even the famous came to Joliet's neighborhoods, as was the case when tenor Enrico Caruso visited St. Anthony's Church, the parish of his childhood friend Father Tonello, and sang with the choir during a Sunday mass. Following the service, Caruso purchased a team of horses at the Joliet Livery Stable on Jefferson Street to help the good father to administer to the poor.

Every neighborhood has its own identity, and in the 1930s, Bluff Street was alive with the sounds of children playing kick-the-can on limestone sidewalks while the men played Skabille, a card game. Greek merchants owned a variety of shops including meat markets, restaurants, bakeries, and "caffenios" or "coffee emporiums," strictly for men.

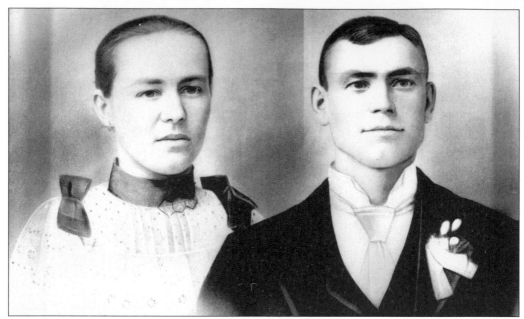

**SURINAK WEDDING.** George Surinak arrived in Joliet in 1892, and Veronica Blazek in 1894. Both were immigrants from Slovakia. After settling on Joliet's east side, they met, married, had a family of four children, and joined St. Cyril's Parish at 704 Landau Avenue. They owned a home next to the parish school at 607 Henderson Avenue. George worked as a section hand for the railroad. (Private collection.)

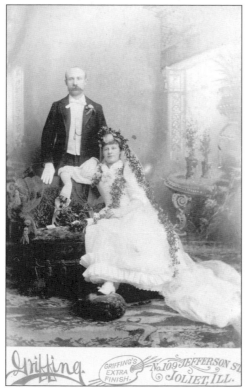

**SWEDISH IMMIGRANTS.** Swedish Immigrants Mr. and Mrs. Andrew Anderson are shown in their wedding photograph around 1900, taken at Griffing Studio. Like other photographic studios at the time, Griffing utilized the photograph to advertise not only their address, No. 109 Jefferson Street in Joliet, Illinois, but "Griffing's Extra Finish" service. (Courtesy of Joliet Area Historical Museum.)

**BROCKMAN WEDDING.** Clara Lena Thurm married William Carl Brockman on October 1, 1902, at her parents' home on Water Street. The bride was a talented, professional seamstress, making the two-piece wedding gown with under slip and attached train shown in the picture. The Brockmans were charter members of Joliet's St. John's English Lutheran Church. (Courtesy of Joliet Area Historical Muscum.)

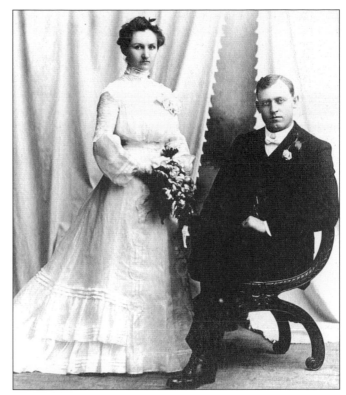

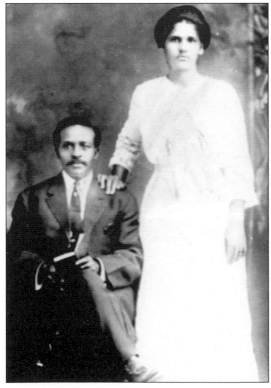

**MR. AND MRS. ROBERT KEYS.** In the 1900 census, 1,800 African Americans were reported in Joliet. This was brought about due to the increase in employment opportunities. Robert Keys and his wife posed for their wedding photograph in 1903. The couple would have four children. (Courtesy of Joliet Historical Museum.)

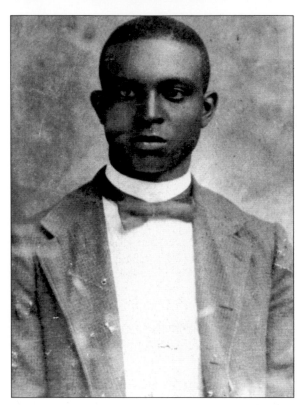

CHARLES "BUD" FUQUA. An early population census of Will County reveals the first African American settlers around 1853. Between 1865 and 1880, some 600 families would establish permanent residence in the community. The record is incomplete about Charles Fuqua, an early black settler in the Joliet area. (Courtesy of the Joliet Historical Museum.)

FAMILY PORTRAIT. Benjamin Gregory and his family were early residents of the Joliet area. In this undated photograph, Benjamin and his wife, Frances, are shown with their children Horace, Nathaniel, James, Amelia, and Roberta Mae. (Courtesy of the Joliet Historical Museum.)

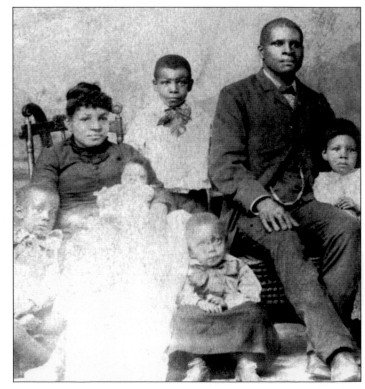

**LYTON PARKMAN.** Lyton Parkman served his hometown and his country during World War I. On November 11, 1918, Joliet's industries blew whistles and horns signaling the war had finally come to an end. By 1920, Joliet's African American population rose to 3,100 and as a constituency began to play an important role in the community. (Courtesy of Dorothy Young-Jones.)

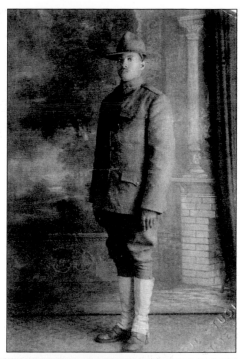

**NELLIE PIERCE.** Lifelong Joliet resident Nellie Pierce was 97 years old when she died on August 16, 1985. Nellie was the only child of Martha McDongall and Elmer E. Pierce. Nellie was a member of the library staff at the Joliet Public Library from 1907 until 1959. She was a charter member of the Business and Professional Women and a life member of the Central Presbyterian Church. (Courtesy of the Joliet Area Historical Museum.)

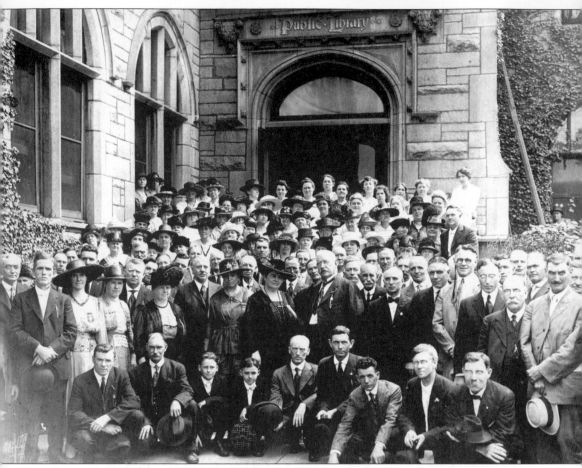

JOLIET PUBLIC LIBRARY. In May 1902, the Joliet Library Board selected the Chicago Architectural firm of D. H. Burnham and Company to design a new library to be built at Clinton and Ottawa Streets. Burnham had gained fame 10 years earlier as the city planner supervising the layout and construction of the 1893 World's Columbian Exhibition held in Chicago. Local resident and library board member Col. John Lambert, president of American Steel and Wire at the time, donated more than $42,000 to secure the project. German stonemason Adam Groth, founder of the Adam Groth Company, was the local contractor. When the doors opened to the public on December 14, 1903, this library, constructed from Joliet limestone, had electric and gas lighting, steam heat, indoor plumbing, and large well-lit reading rooms. Today the building remains one of Joliet's grand landmarks. (Courtesy of the Joliet Area Historical Museum.)

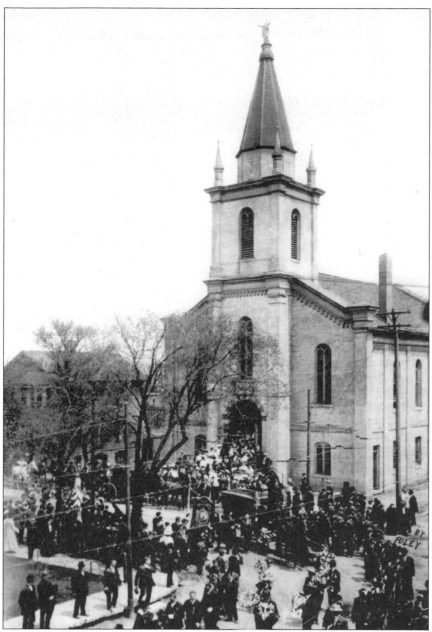

**LEADER OF JOLIET ITALIANS LAID TO REST.** It was said that every Italian in Joliet old enough to walk and many more who were not Italian formed the largest funeral cortege ever witnessed in Joliet on May 10, 1908, when the remains of John Teapot (originally Giovanni Tipatti), the city's first Italian resident, were carried to their final resting place in St. Patrick's Cemetery. The local news reported the hearse bearing the casket was preceded by banner carriers of men from the six societies of which Teapot was a member. Behind the casket, the members of these organizations walked eight abreast filling the streets followed by 20 hacks and nearly 50 private carriages from St. Anthony's Church. The procession included both the Steel Works brass band and a nine piece Italian band. In all, 623 people marched in the funeral of this influential 6th Ward saloon keeper known as "the father of Italians in Joliet." (Courtesy of Michael A. Vidmar.)

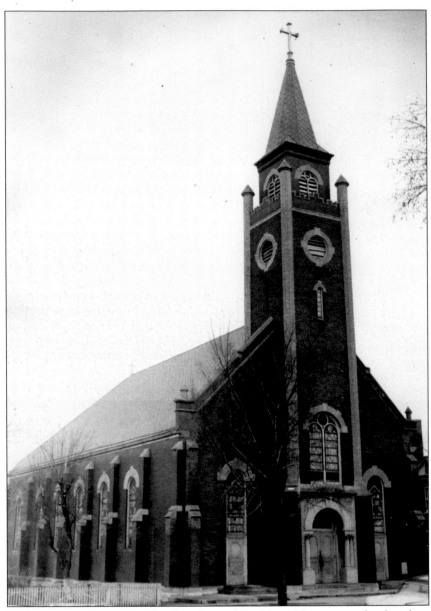

**ST. MARY NATIVITY CHURCH.** The founding of St. Mary Nativity is closely related to the digging of the Illinois and Michigan Canal, and the steel mill operations of Joliet. Jobs on the canal and mills were readily available and attracted the early Croatian immigrants. As the canal progressed southward, the Croatians followed, settling along Slovenian Row. Led by Lawrence Zema, discussions were held and an offer made to Anton and Antonia Mur, owners of two lots in the area known as North Joliet. When Anton learned that a place of worship would be erected on his site to honor the "Blessed Virgin Mary," he considered it a compliment to sell the property for the purpose of building the church as his daughter's name was Maria. In April 1904, Will County recorder of deeds, Ervin T. Geist, would deed the property to "St. Mary's Catholic Kroatian Church." By 1905, the cornerstone was laid "in the presences of many thousands of devout Catholics from every church" in Joliet. The first mass was held on Christmas Eve 1906, in a temporary school hall. (Courtesy of St. Mary Nativity Church.)

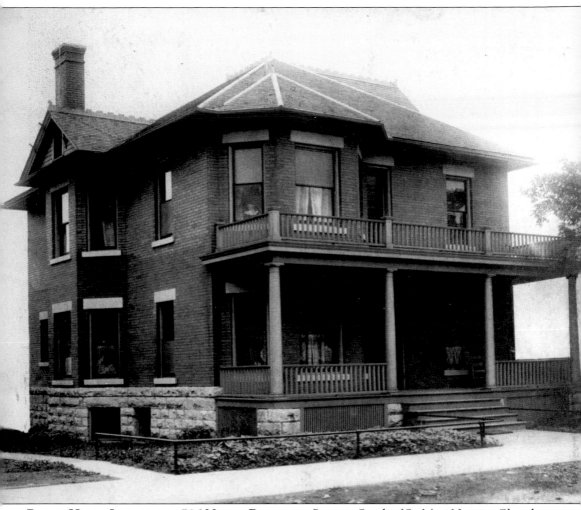

**PARISH HOUSE LOCATED AT 706 NORTH BROADWAY STREET.** South of St. Mary Nativity Church sits the pastor's residence made of a stone foundation with a brick superstructure. In its 100-year history, the parish has had four pastors. In 1906, Rev. George Violich arrived from Dalmatia, a region of Croatia, becoming pastor of St. Mary "Catholic Croatian" Church until his death in 1939. Appointed as associate in 1937, Fr. Aloysius Sinsky became the parish administrator and served as the second pastor from 1950 until his retirement in 1986, and was instrumental in much of the parish development. In July 1986, Fr. David J. Stalzer succeeded Sinsky as the third pastor. Greatly loved by the parishioners, Stalzer was responsible for many parish renovation projects. The fourth and current pastor, Fr. Christopher Groh was appointed pastor in 1999. Groh also serves as administrator of Holy Cross Church and is police and fire chaplain for Joliet. Under Groh's direction and spiritual guidance, St. Mary's continues to be one of the most prosperous of Joliet's Catholic congregations. (Courtesy of St. Mary Nativity Church.)

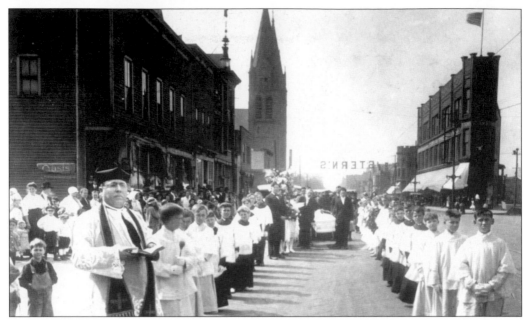

**ANTHONY RUDMAN FUNERAL ON NORTH CHICAGO STREET.** On May 16, 1917, this funeral procession carried the remains of 13-year-old Anthony Rudman from his home in the 400 block of North Chicago Street. Led by Rev. George Violich, pastor of St. Mary's Croatian Catholic Church, the mourners marched north over the Des Plaines River on the Ruby Street bridge reaching the church at 706 North Broadway for services. This view looks south down Chicago Street at what was the Slovenian Row district. St. Joseph Catholic Church stands on the left. The sign strung over the street in the distance reads "Stern's," a popular retailer of general merchandise at the time, located one block west on Indiana Avenue. (Courtesy of St. Mary Nativity Church.)

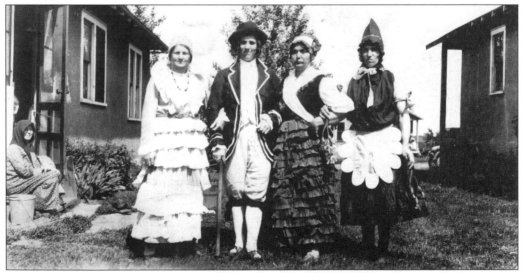

**NIGHT OF THE GYPSY.** This photograph depicts Amalia "Molly" Blascovich and friends celebrating "the night of the gypsy" on the eve of Ash Wednesday. Held prior to the start of the Lenten season, this once-popular evening tradition in many of the Catholic churches was an event similar to a Mardi Gras celebration, with costumes, music, and dancing. (Private collection.)

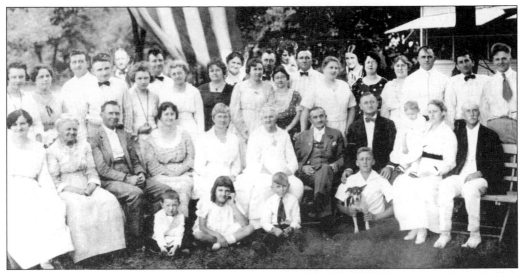

**WUNDERLICH 50TH ANNIVERSARY.** Ernst and Margaret Wunderlich celebrated their 50th wedding anniversary in 1919. The couple had seven sons and all but William, who would go into the undertaking business, were engaged in the gravestone trade that bore their father's name, E. Wunderlich Granite Company. The shop opened up in 1874 at 804–808 North Hickory Street. Seated on the ground are, from left to right, Glen, Gretchen, Russell, and Ernst with the dog; (second row) Amelia Wunderlich, ? Faust (mother-in-law of William), James Steiner, Laura Wunderlich, Minnie Schuessler, Margaret Geipel Wunderlich, Ernst Wunderlich, William Wunderlich, Leona Geipel, Mamie Geipel, and Ernest Geipel (brother of Margaret). Those standing include Joseph Steiner, Stella Fritz, Elsie Fritz, Hazel Byrd Wunderlich, Ernst Wunderlich Jr., Melton Wunderlich, Dr. ? Schuessler, and Elma Fritz Wunderlich (Milton's wife), among others. Ernst Wunderlich Sr. passed away in 1923. (Courtesy of the Joliet Area Historical Museum.)

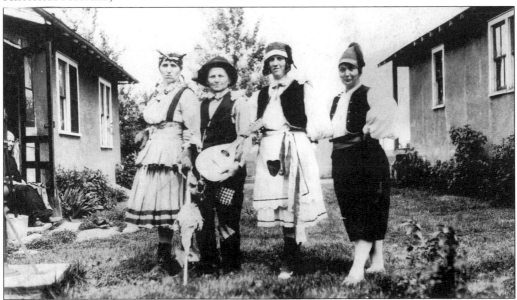

**CROATIANS IN COSTUME.** Costumed friends celebrate the Night of the Gypsy in the Croatian neighborhood. (Private collection.)

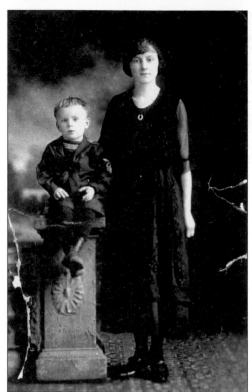

**MOTHER AND SON.** Anna Kahut and her son, Joseph, are in this 1922 photograph. Members of St. Cyril's Parish on Joliet's eastside, Anna's husband, Joseph Kahut Sr., died of walking pneumonia. Unable to raise her son alone, Anna went to work for the American Can Company, placing young Joseph in the care of the Sisters of St. Francis of Mary Immaculate. The sisters took in orphaned, dependent, and needy children as boarders at the Guardian Angel Orphanage located on Buell Avenue. During the early 1920s, the orphanage served 300 children including Joseph. In 1926, the Buell Avenue location became St. Francis Preparatory School until it was sold in 1961. Today the Cathedral Area Apartments stand in its place. (Private collection.)

**GEČAN WEDDING PICTURE.** On October 28, 1923, Anna Kahut married Charles Gečan. From left to right are Mary and Joseph Kaduchak, Cecilia and Valley Branshaw stand behind Charles and Anna, and Anna Ring and Joseph Surinak are to the immediate right of the newlyweds. The couple on the far right is unidentified. After Charles and Anna wed, Gečan adopted Anna's son, Joseph, bringing the young lad home from the Guardian Angel Home to live with them. (Private collection.)

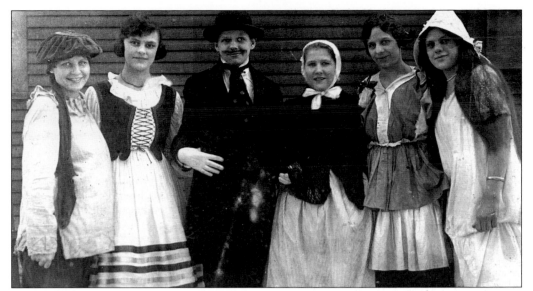

**HOLY CROSS PARISH.** These members of one of the four Holy Cross parish societies pose in the snow prior to a festival. The women are dressed in traditional native Polish costumes. The building of the Holy Cross church began in April 1901, and with the appointment of Fr. Francis Jajlsizi of Milwaukee, the parish building project was completed. Holy Cross Polish Church was dedicated on June 15, 1902. The red brick church with white stone trim stands one block north of Ruby Street at the southeast corner of Elizabeth at Ross Streets. Polish mass is still held on Sunday mornings at 10:30. (Courtesy of the Joliet Area Historical Museum.)

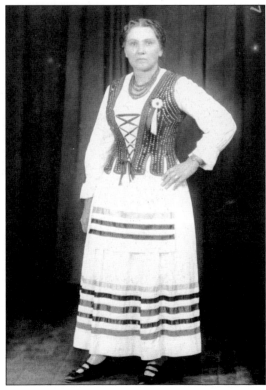

**POLISH COSTUME.** This woman is dressed in her native costume, possibly for an annual procession or celebration in Joliet's Polish community. (Courtesy of the Joliet Area Historical Museum.)

21

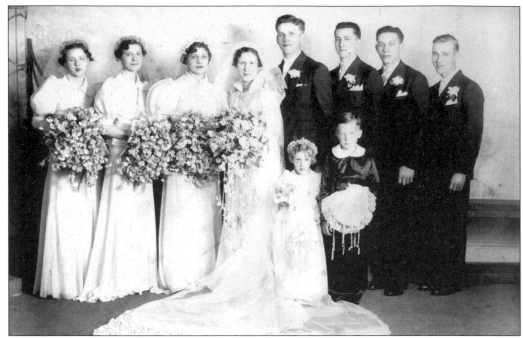

**TRIZNA WEDDING.** Joseph R. Trizna married Cecilia Branshaw on June 16, 1937. Pictured in the wedding party, from left to right, is unidentified, Bernice Kaduchac, unidentified, Cecilia, Joseph, Tony Trizna, unidentified, and Frances "Fritz" Branshaw, the brother of the bride. Marianne Branshaw is the flower girl and George Kaduchac is the ring-bearer. Trizna was elected sheriff of Will County from 1962 to 1966 and again from 1970 to 1978. (Private collection.)

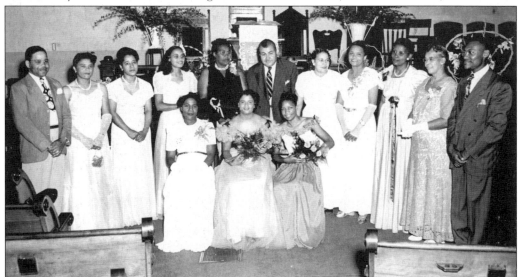

**SECOND BAPTIST SPRING CANTATA.** Chastine C. Mason, sixth from the left, stands with Spring Cantata performers in 1950. Mason was editor and publisher of the Brown Book listing Joliet's who's who in the African American community during the 1950s. He also published the *Negro Voice*, a weekly newspaper serving the suburban areas of Chicago. A Joliet Township High School graduate, Mason was employed as the chief engineer at the Woodruff Hotel in Joliet from 1915 to 1942. (Courtesy of Second Baptist Church.)

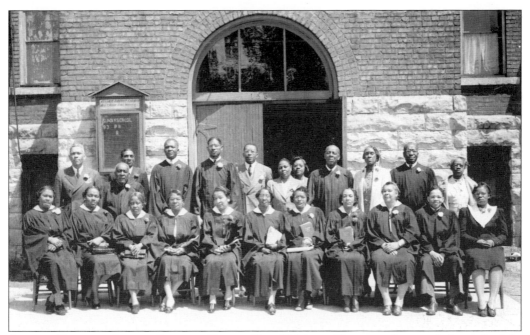

**SECOND BAPTIST ADULT CHURCH CHOIR.** Rev. T. Moore King, standing sixth from the left, served as the minister of the Second Baptist Church when members of the church choir and gospel choir met to rehearse before services in this undated photograph. Reverend King served his congregation for 21 years before passing in 1956. (Courtesy of Second Baptist Church.)

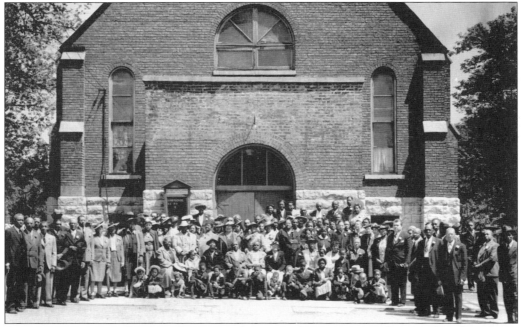

**CONGREGATION OF SECOND BAPTIST CHURCH.** Prize-winning photographer Joseph D. Matthews photographed the congregation of the Second Baptist Church outside of the church building on a beautiful Sunday. Matthews was a member of the Illinois Professional Photographers Association. (Courtesy of Second Baptist Church.)

**Technical Sgt. Sator "Sandy" Sanchez Memorial.** This memorial recognizes the heroic contributions of Sator "Sandy" Sanchez for his country. Sanchez's combat career with the 8th Air Force, 95th Bomb Group, 334th Bomb Squadron, began in 1943. The 23-year-old Joliet native served three tours of duty, flying 66 combat missions. On March 15, 1945, Sanchez manned the top gun turret position for a combat mission from the 15th Air Force stationed in Italy to bomb an oil plant in Ruhland, Germany. The aircraft was hit by flak and all crew members except Sanchez were able to bail out. The plane exploded, and Sanchez's body was never recovered. (Courtesy of the Joliet Area Historical Museum.)

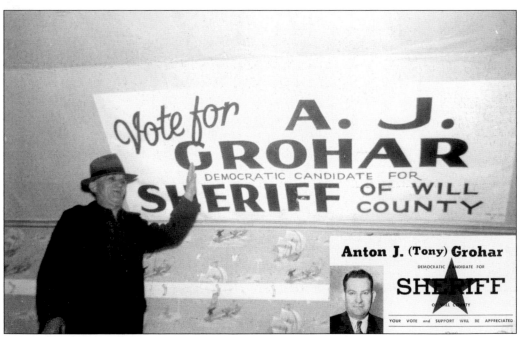

**Vote for Grohar.** Elections brought politicians to the neighborhoods, especially at the local taverns. These two signs ask the voters to support Democratic candidate A. J. Grohar for sheriff. Grohar lost the election. (Courtesy of Peter Papesh.)

SEN. JOHN F. KENNEDY. Sen. John F. Kennedy glances at his speech while being escorted through the Louis Joliet Hotel by Chief of Police Joseph R. Trizna, to the right of the senator, and unidentified Secret Service agents behind him, during a presidential campaign stop in Joliet's downtown area on October 25, 1960. (Courtesy of Marcy Autero.)

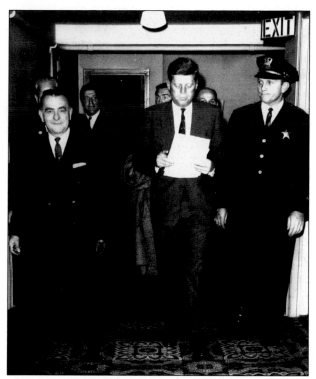

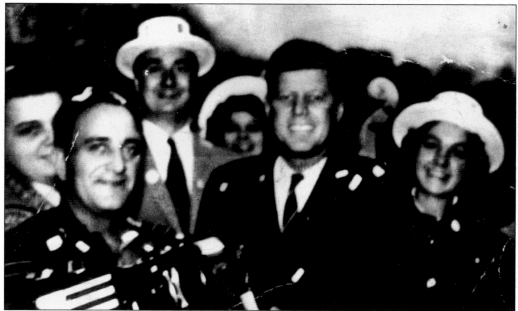

KENNEDY COMES TO TOWN. Senator Kennedy's motorcade left the massive rally and traveled through Broadway Street on its way to Chicago's western suburbs. Democratic precinct committeeman Ralph Papesh managed to flag down the caravan and persuade the candidate to meet his father, John Papesh. Pictured here in the Papesh yard are Bobbie Doszak (far left), Pete "Crazy Otto" Semplinski with accordion, Ralph Papesh (white hat behind Kennedy), John F. Kennedy, and Marge Papesh to the right of the senator. (Courtesy of Peter Papesh.)

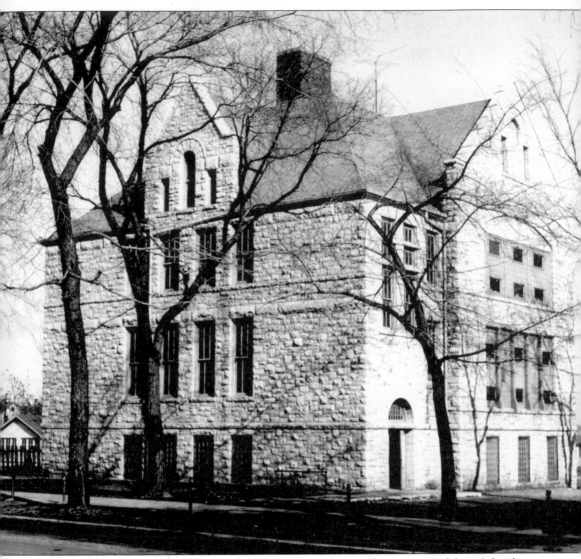

**NORTH HICKORY STREET.** The stately building was primarily constructed from Joliet limestone mined in local quarries. For years, the building at 820 North Hickory Street served residents of this Joliet neighborhood in a variety of ways. Initially the Hickory Street School, it would also serve as a youth center and school for St. Mary Nativity after a 1954 fire destroyed a portion of their grade school. The American Legion St. Joseph's Park Post 1080 purchased the property in 1956 and renovated the building. Many neighborhood residents remember accompanying their grandmothers there on Sunday afternoons to play bingo. There was also an annual Easter egg hunt, many dinner dances, and New Year's Eve parties. By 1966, the legion leased a portion of the property to the Joliet Park District for a neighborhood playground. Post 1080 occupied the site until February 1995, when a fire destroyed the building. Today the property is Legion Park. (Courtesy of St. Mary Nativity Church.)

**KING FAMILY REUNION.** The family reunion of the children of Tom and Pauline King Jr. captures the "Spirit of 1976" in its celebration of personal style and American individualism. The Kings were among the families to establish residences in Joliet during the Great Migration, a mass exodus of black southerners who moved north to fill labor shortages in factories during both world wars. (Courtesy of Joseph Nathan Baines Jr.)

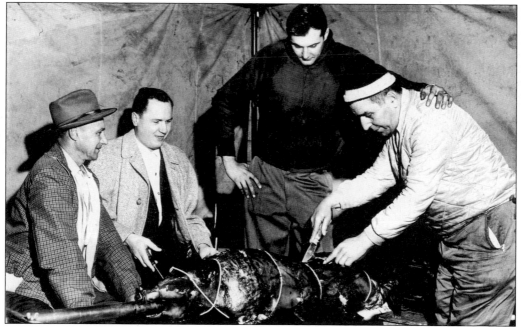

**NEIGHBORHOOD BARBECUE.** During the first week in April 1975, a very late winter storm paralyzed parts of northeastern Illinois with up to 20 inches of heavy, wet snow. Pictured under a tent protecting the cooks during the annual neighborhood feast are, from left to right, Sylvester "Gibbles" Kevish, Joseph "Chach" Wolf, Bernard Silakawski, and George "Suitcase" Sutica. (Private collection.)

**JOHN BOURG RE-ELECTED MAYOR.** John P. Bourg Jr. served two terms as mayor of Joliet from 1979 to 1987. Dedicated to Joliet's citizens, he was responsible for neighborhood improvement programs, and major sewer and road upgrades were planned under his administration. Born and raised in Joliet, Bourg was a graduate of St. John's Grade School, Joliet Catholic High School, Joliet Junior College, and Lewis University. He was a U.S. Army Korean War Veteran and served as a councilman before becoming mayor. Bourg died in 1993. (Private collection.)

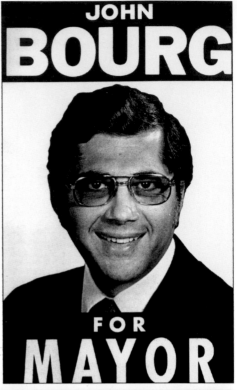

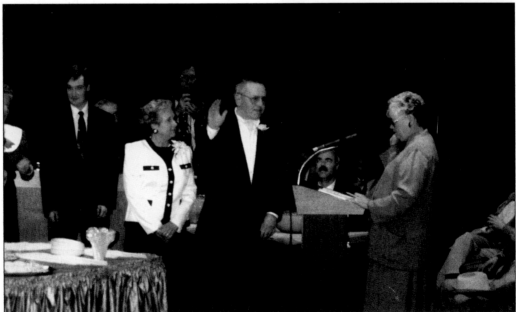

**MAYORAL CEREMONY.** Arthur Schultz takes his mayoral oath in 1995 inside the Joliet city council chambers as his wife, Francis, stands at his side. Arthur won his first mayoral election in 1991, becoming the 38th mayor of Joliet. Born and raised in Joliet, after a police career spanning 29 years, he retired from the force following his election. He is a 1998 inductee into the Joliet/Will County Hall of Pride. (Private collection.)

# Two

# SLOVENIAN ROW

In the late 1800s, the lure of the Midwest drew the first Slovenian settlers to Joliet in great numbers. Slovenians were under the rule of the Austrian Empire and were often referred to as "Austrians." These first Slovenians established their community primarily in the north section of town, bordered by the Des Plaines River on the west, by Ruby Street and the steel mill yards on the north, the Santa Fe railroad tracks on the east, and on the south by Jackson Street. By 1891, some 73 Slovenian families lived in Joliet, most of them depending on work in the expanding steel industry, with companies such as American Steel and Wire. Devoted Catholics, these immigrants formed a committee of influential merchants in the Chicago-Scott Street area to raise funds for their own parish with quarryman Markus Kraker, Joliet's first Slovenian, donating stone to build St. Joseph Church on the site. Working through Rev. John Solnce, originally from Slovenia and attending to the spiritual needs of Slovenians in America, these settlers petitioned for a priest from their native land to become their pastor. Solnce knew a young energetic priest from their homeland and convinced him to come to Joliet. On May 12, 1891, Archbishop Patrick A. Feehan of the Chicago Diocese appointed Rev. Francis S. Sustersic the organizer and first pastor of St. Joseph. Sustersic was a good pastor but also a loyal Slovene and a prolific writer. His book, *Podnik Rojakom Slovencom*, aided unwary Slovenian immigrants upon their arrival in America.

"Slovenian Row" was part of Joliet's second ward. By the early 1900s, the Slovenians operated 19 saloons, five dry goods and grocery stores, three meat markets, one funeral parlor, and one cigar manufacturer. Many of these same individuals organized a Slovenian fraternal organization establishing the American Slovenian Catholic Union (K.S.K.J.) in April 1894. The first Slovenian newspaper in America, *Amerikanski Slovenec*, moved to Joliet in 1899. The first Slovenian physician in the United States was Dr. Martin Ivec, who opened his office at 900 North Chicago Street in 1904. By 1913, ten percent of Joliet's population was Slovenian, making it the second largest Slovenian community in America, surpassed only by Cleveland, Ohio.

**A Page from *Drzavljanski Katekizem*.** Becoming a citizen was as an important part of the immigrant experience as finding a job in America. Any time during the first three years of an immigrant's residence in the United States, he or she could apply for "Declaration of Intention." Then after being in the United States five years, final papers could be applied for. The Slovenian edition of *Drzavljanski Katekizem* contained 87 pages about the naturalization process that had to be learned before receiving a Certificate of Naturalization. (Courtesy of Angela Zaida.)

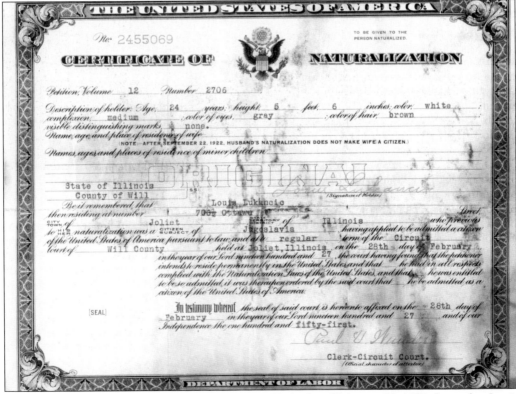

**Certificate of Naturalization.** Certificate 2455069, dated February 28, 1927, shows that Louis Lukancic finally fulfilled his dream to become an American citizen. (Courtesy of Angela Zaida.)

**THE CORNER OF 1000 NORTH CHICAGO STREET.** Slovenian immigrant Anton Nemanich was involved in a variety of businesses in the area of Chicago, Ohio, and Scott Streets. The Nemanich block began at his home, at the corner of 1000 North Chicago Street, and was for many years the cornerstone to Slovenian Row. Between 1908 and 1920, the address would be the home of the Anton Nemanich family. On the second floor, Nemanich provided apartments for boarders newly arrived from Slovenia. Many immigrants unable to speak English had a card pinned to their coats addressed, "Tone Nemanic, Joliet, Illinois." Reaching the Joliet train depot, immigrants would be met by Nemanich driving a team of horses hitched to a large delivery wagon. He would take the men to Stevens Men's Clothing Store on Chicago and Indiana Streets where he would buy them work clothes, shoes, and a tin lunch pail. This photograph was taken in 1920. (Courtesy of Mardell Keenan.)

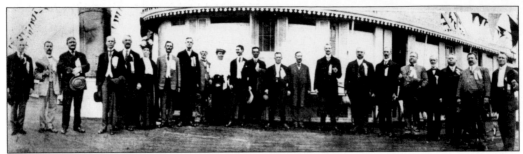

**WILLIAM H. TAFT.** William H. Taft was the U.S. Secretary of War from 1904 to 1908. Taft, seventh from the right, and Anton Nemanich, alderman, second from the right, are pictured with Joliet dignitaries. (Courtesy of Mardell Keenan.)

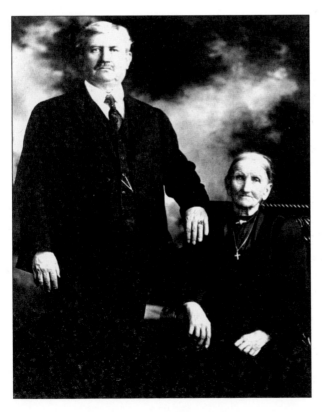

**ANTON NEMANICH WITH HIS MOTHER, CATHERN.** Cathern Skoff Nemanich was born in Metlika, Austria, and married Anton Nemanich. They had five children, John, Anton, Math, Cathern, and Barbara. She had more than 30 grandchildren. She is pictured here with her son, Anton. (Courtesy of Mardell Keenan.)

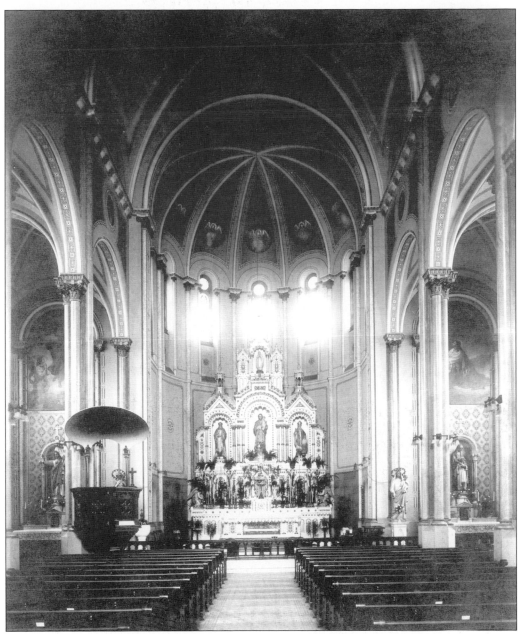

**St. Joseph Church, 416 North Chicago Street.** By 1896, there were 200 Slovenian families in St. Joseph's parish, 127 more than five years earlier. The number of industrial employees had doubled in Joliet, indicating the availability of jobs for immigrants, so both the job market and a Slovenian church in Joliet account for the rapid growth of the parish. By 1904, groundwork began for a new larger church, the first stone and steel structure in the city at Chicago and Clay Streets. The church was constructed of "Buff Indiana Bedford" limestone, and the architect was W. J. Brinkman. Adam Groth was the contractor. Upon its completion, it was the largest and grandest church in Joliet. Today it remains, as evident in this c. 1930 photograph of the inside of the church, as a beautiful edifice giving the Slovenian community recognition and respect from outside of its district. (Courtesy of Josephine Erjavec.)

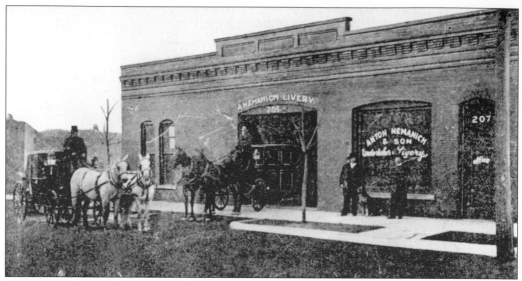

**A. Nemanich and Son Undertaker and Livery.** The location of A. Nemanich and Son Undertaker and Livery was 205–207 Ohio Street. This 1905 photograph shows two teams of the more than 18 horses (some from Kentucky) housed at the livery. The cost to bury a person was $50. A black hearse and team of black horses was used for adults, while a white hearse and white horses were used for children. The carriages were upholstered on the inside with green velvet, and the windows were adorned with green tassels. Caskets made of plain boards were lined with white muslin, tucked and pleated on the inside. (Courtesy of Mardell Keenan.)

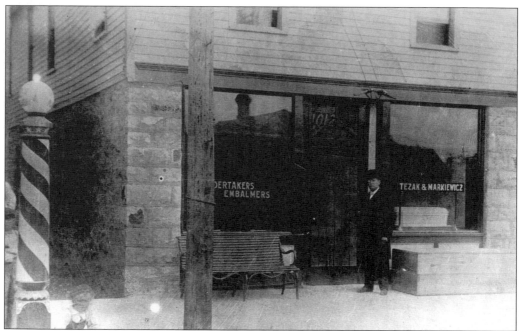

**Tezak and Markiewicz Funeral Home.** John Tezak and S. Markiewicz, undertakers and embalmers, began their partnership on March 1, 1908, at 1012 Chicago Street. As Joliet grew and prospered, so did the funeral home. (Courtesy of Jack Tezak.)

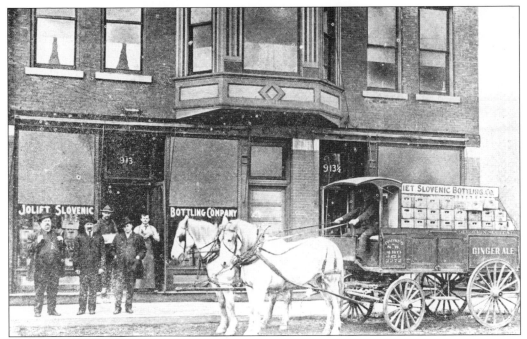

**JOLIET SLOVENIC BOTTLING COMPANY.** Anton Nemanich incorporated Joliet Slovenic Bottling Company in 1906. The company was located at 913 Chicago Street. In a 1973 letter written by one of Nemanich's daughters, Frances, to her granddaughter Jeanne, she recalled how, "Soft drinks were produced with delicious syrups made the day before with 100 pound bags of sugar added to flavors of strawberry, vanilla, root beer, orange, chocolate, and a white soda for use with mixed drinks." The company delivery wagon is pictured with cases of bottled soft drinks. (Courtesy of Mardell Keenan.)

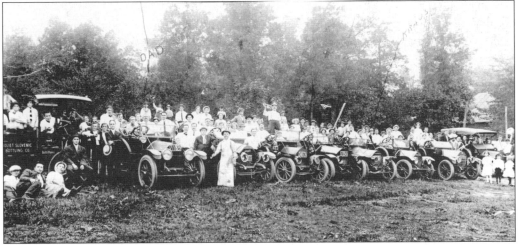

**JOLIET SLOVENIC BOTTLING COMPANY PICNIC.** The stock holders and Anton Nemanich, owner of the Joliet Slovenic Bottling Company, invited employees and their families, along with local Slovenian tavern owners to this daylong picnic filled with ethnic food, music, and games during the summer of 1913. At the time, Anton Nemanich was also a partner in the Slovenian Liquor Company (wholesale distributor) producing bonded whiskey sold throughout Illinois, Indiana, Wisconsin, Minnesota, New York, and Pennsylvania. (Courtesy of Mardell Keenan.)

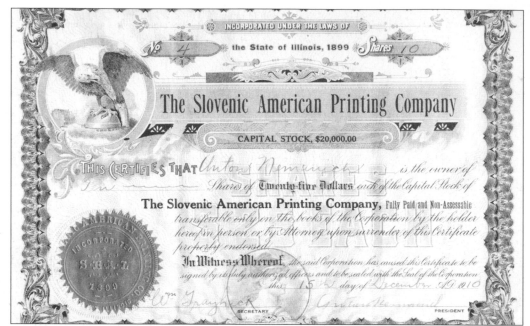

**THE SLOVENIC AMERICAN PRINTING COMPANY.** The Slovenic American Printing Company published the *Slovenian American Weekly* newspaper on the corner of Scott and Clay Streets. Articles were printed in both Slovenian and English. Anton Nemanich played a major role in starting the printing company and the newspaper until it was purchased by the Glasilo Paper Company and moved to Cleveland, Ohio. Stock certificate No. 4 shows 10 shares of the printing company issued to Anton Nemanich on December 15, 1910. (Courtesy of Mardell Keenan.)

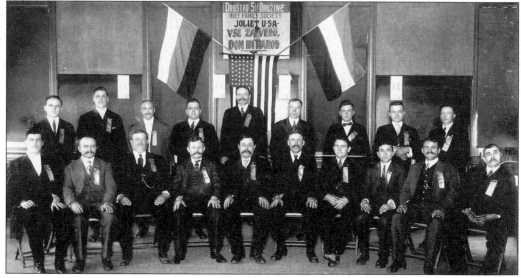

**DRUZBA SV. DRUZINE (THE HOLY FAMILY SOCIETY).** Incorporated on May 14, 1915, this photograph taken the same year shows the officers of the Slovenian Holy Family Society of Joliet. The inscription on the sign in the photograph translates as "All for the faith, home and nation." Nicholas J. Vranicar is second from the right in the second row. Others pictured include Frank Tushek, Andrew Glavoch, Stephan Kosar, Joseph Pavlakovic, John Nemanich, and Frank Less. (Courtesy of Frank Vranicar.)

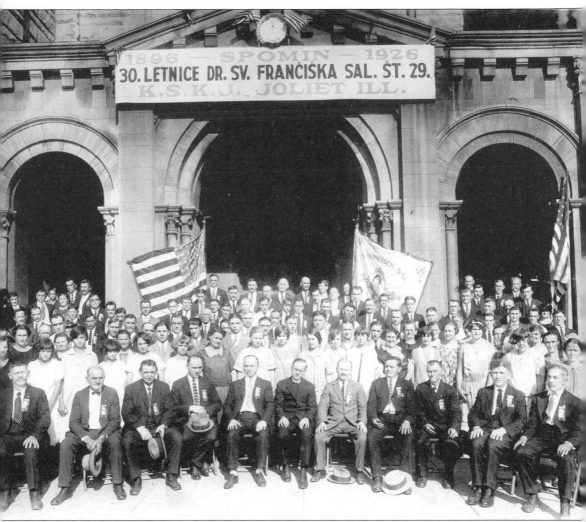

**KRANJSKA SLOVENSKA KATOLINSKA JEDNOTA LODGE 29.** Members of St. Francis de Sales Lodge No. 29 K.S.K.J. (Kranjska Slovenska Katolinska Jednota, American Slovenian Catholic Union) are pictured on the steps of St. Joseph's Catholic Church in the summer of 1926 during the 30th anniversary celebration. Anton Nemanich Sr. and Joseph Panian organized Lodge 29 on February 2, 1896, in Nemanich's Tavern on Scott Street for the express purpose of aiding the K.S.K.J. along with four other Joliet Slovenian lodges to reach the goal of 1,000 members necessary for incorporation in the state of Illinois. Within its first week, Lodge 29 numbered 76 members. The Lodge sponsors religious, social, and fraternal events, which keep the religious and ethnic heritages alive and flourishing. It also helps those in need, members and non-members alike. (Courtesy of Josephine Erjavec.)

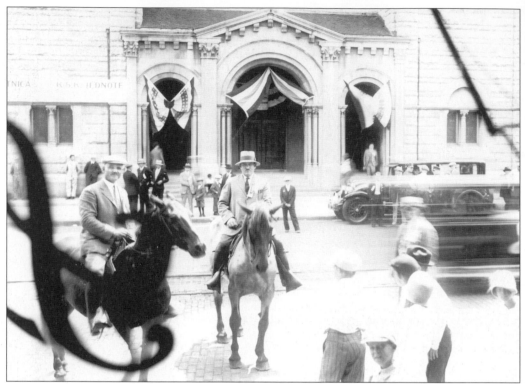

NORTH CHICAGO STREET. North Chicago Street at Scott Street was the anchor of the fast-growing Slovenian community. Zema's Drug Store stood at 431 North Chicago Street, across from St. Joseph Catholic Church. This 1928 photograph was taken from inside the building looking east at the church. Jacob Sega (left) and Joseph Bozich ride on horseback as the neighborhood children look on. Flags above the steps and a sign on the church announce a celebration of the Kranjska Slovenska Katolinska Jednota. Today, the Slovenian Women's Union Heritage Museum and Fraternal Organization has replaced the drug store. (Courtesy of William and Diane Govednik.)

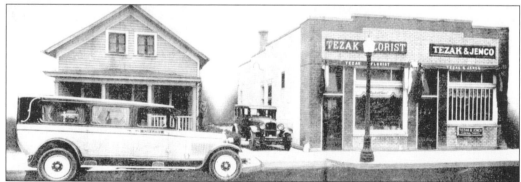

TEZAK AND JENCO FUNERAL HOME. In 1924, the funeral business added Tezak Florist. Markiewicz was replaced by Jenco, and the business moved to 457 Indiana Avenue. The parked car shown between the funeral home and neighboring residence is the same car shown in the next picture decked out with American flags for a parade. The two-toned hearse, with its curtained windows, cross, and white hub caps was a stately presence on Chicago Street. (Courtesy of Jack Tezak.)

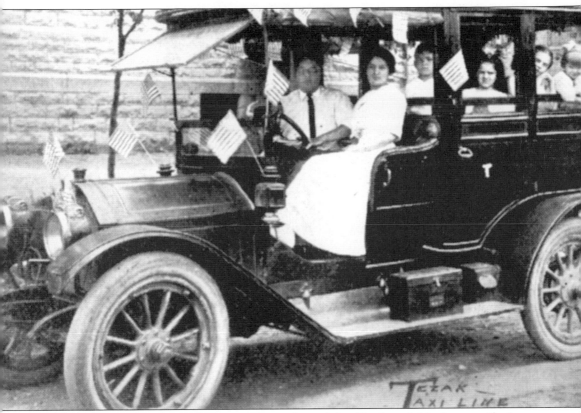

**Tezak Car Participates in Parade.** Shown here, John Tezak and his future wife, Jean Ditchman, accompanied by the Zalar children, participate in a parade in Joliet. As a joke, the car was tagged the "Tezak Taxi Line" in this photograph. But it would be anything but a joke when in 1928 Tezak was murdered. A drunken employee walked into the funeral home one night with a loaded shotgun, shooting Tezak in the chest. Left with four sons between the ages of four and 11, and a partnership in the business, Jean Tezak made an unusual move for a woman in the early 20th century; she became the first female licensed funeral director in Will County and managed the Tezak Funeral Home until her sons assumed ownership. Today, the Tezak Funeral Home and Cremation Center is owned and operated by two of John's grandsons John F. "Jack" and Richard K. "Dick" Tezak at 1211 Plainfield Road. (Courtesy of Jack Tezak.)

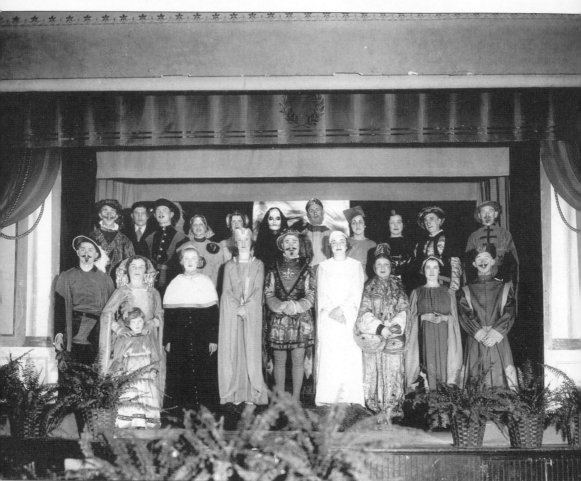

**SLEHERNIK.** This 1935 photograph shows the cast of *Slehernik*, the dramatic presentation put on for the parishioners on May 7 at St. Joseph's Hall. Cast members dressed in their costumes from left to right are (first row) Louis Verbich as Prijatelj, Catherine Stefanich as Žena, in front of her is junior cast member Dolores Klepec as Dete, Mary Rolih as Pokora, Julia Verdnik as Vera, Paul Laurich in the role of Slehernik, Dorothy Zlagar played Krepost, Mary Strmec as Bogastvo, Joanne Zupancic in the role of Sestrična, and Frank Horvat as Bratranec; (second row) Joseph Horvat in the role of Veseljak, Edward Svetich as Glas Božjl, John Vidmar in the role Veseljak, Čut was played by Mary Dolinšeh, Leona Simer as Lepota, Joseph Laurich in the role of Smrt, Bernard Kambich as Skrivnostna Postavia, Helen Zlogar as Modrost, Lucille Umek as (V)oč, Louis Strniša as Veseljak, and Raymond Liberšer as Veseljak. (Courtesy of Josephine Erjavec.)

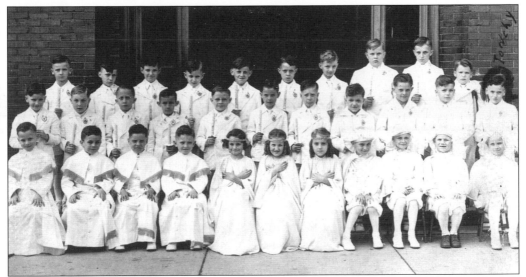

**FIRST HOLY COMMUNION.** This photograph shows the 1942 first communion class on the steps of St. Joseph's Church. From left to right are (first row) Donald Kramich is seated on the far left end; (second row) Anthony Kambic, Robert Planek, Gene ?, ? Cook, Robert Horvatin, Jerry Nasnbenny, Robert Turich, Donald Conda, Robert Vernesich, Lawrence Fergenson, and Anthony Wolf; (third row) Raymond Petric, Donald Hulbert, David Meruzic, James Wedic, Leonard Vesich, Rudolph Turk, two unidentified boys, Blaze Turk, and Alfred Horky. The other children, angels, and pages in the ceremony are unidentified. (Courtesy of Anthony Wolf.)

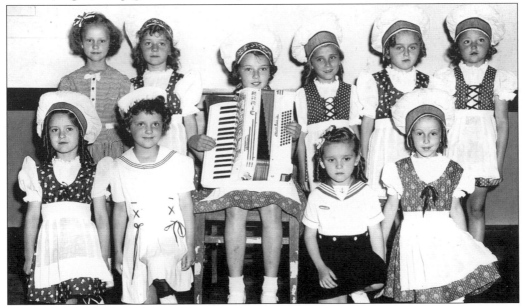

**FIESTA DAY PROGRAM CELEBRATES FATHERS IN 1943.** These junior members of the Slovenian Women's Union Branch 20 honored their fathers at the Fiesta Day program. The girls took the stage after an army show held on Father's Day 1943, at Rivals Park. The junior members are, from left to right (first row) Kathryn Stimac, Francille Vranicar, Marie Cinkovic (with accordion), Diana Ramuta, and Jeanette Babich; (second row) Geraldine Jevitz, Beverly Gregory, Rachel Liker, Donna Nahas, and Rita Vancina. (Courtesy of Josephine Erjavec.)

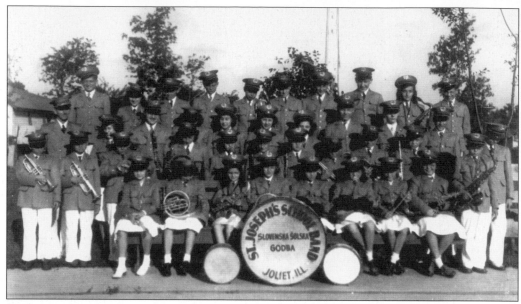

**St. Joseph School Band.** Pictured are St. Joseph's School Band members in their new uniforms and stylish hats. The band, organized in June 1931, presented their first parish concert on August 31 of that year and performed at parades, ceremonies, and other public Joliet events. The first school opened in 1895 with 65 pupils. By 1929, school attendance reached a record peak with 873 students, more than any other grade school in the city. The number of families in the parish rose to 1,116 in 1948. (Courtesy of Ann Bush.)

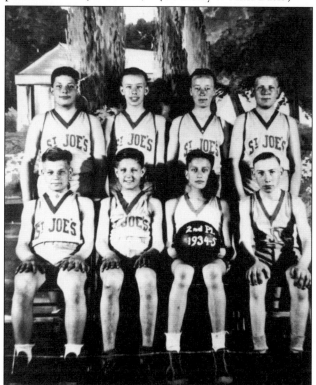

**St. Joseph's Boys Basketball Takes Honors.** The boys' basketball team of St. Joseph's captured second place during the season of 1934–1935. The team members are, from left to right, (first row) Bernard Kren, Anton Culik, Julius Zlogar (with basketball), and Martin Ausek; (second row) William Spelich, Edward Bambic, Raymond Zelatel, and William Horwath. (Courtesy of the Joliet Area Historical Museum.)

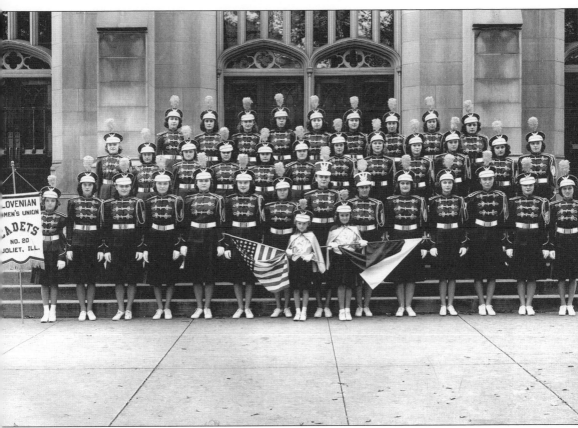

**SLOVENIAN WOMEN UNION HONOR CADETS OF 1942.** Marie Prisland came to America from Slovenia in 1906. She observed firsthand the hardships and difficulties of the female immigrants. In 1926, Prisland founded the Slovenian Women Union of America to financially help Slovenian immigrant women living in America. Through sisterhood and moral support, the union assists women with education, citizenship, and participation in civic affairs. Pictured here are the cadets who captured first place in the competitive Ohio Drill in 1942 and also participated in Joliet's parades and parish celebrations. Josephine Mahkovec was captain, and Mary Legan served as lieutenant. The cadets are Frances Ancel; Mary Bostjancic; Lillian and Lucille Brulc; Olga, Mildred, and Jonita Erjavec; Mayme Frankovich; Genevieve Glavan; Jean Gombac; Jean Govednik; Geraldine Heintz; Marion Jelenich; Dorothy Jevitz; Bernardine and Marie Kastelic; Norrine Kenopek; Mary Kolenc; Loretta Vicich; Marion and Irene Korenec; Anne Kunich; Bernice Kuzma; Elaine Levanduski; Sophie Matkovic; Marie and Theresa Metsh; Mildred Mikolic; Isabelle Musich; Joan Muster; Dolores Pirc; Marie Popek; Irene Planinsek; Rita Stukel; Marie Terlep; and Agnes Smitberger. (Courtesy of Josephine Erjavec.)

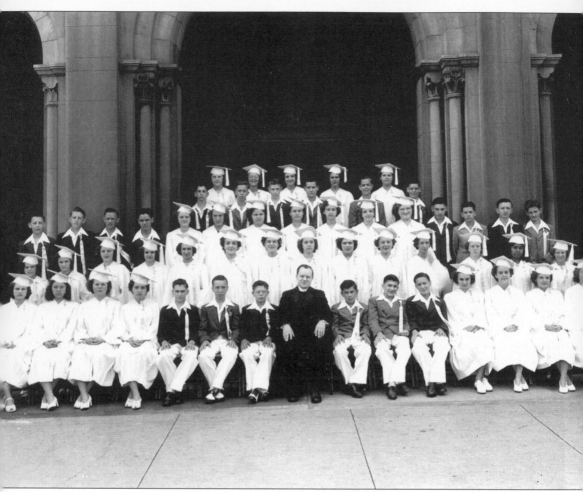

**GRADUATION DAYS ON SLOVENIAN ROW.** St. Joseph Church and School were the cornerstone of North Chicago Street. Rev. Matthias J. Butala, pictured with the graduates, helped bring displaced Slovenians from war-torn Europe to America. The Slovenian immigrants were hard working, devoted to church, and devoted to providing an education for their children. Most of the 1944 graduating eighth-grade class were first-generation Americans. The students are identified as Joseph Bauer, Walter Camp, Robert Dobczyk, George Frankovich, William Gregorich, Patrick Hartney, John Jevitz, James Legan, Stanley Malnar, Bernard Muren, Anton Nemanich, Norman Nemanich, Andrew Oblak, Stanley Papesh, Donald Pomatto, Donald Pruss, Robert Rogel, Joseph Vidmar, Joseph Wolf, Raymond Zameic, Elizabeth Ausec, Doris Bistry, Dolores Bostjancic, Dorothy Bostjancic, Patricia Brulc, Catherine Burich, Zona Chuck, Marie Culik, Eileen Ferkal, Sara Frausto, Lucille Gregorash, Dolores Horvatin, Rosemary Horvatin, Bernadine Ivec, Helen Mutz, Geraldine Kezele, Irene Klemenich, Dolores Klepec, Lorraine Machak, Jean Muster, Anna Petric, JoAnn Pirc, Leona Plut, Mary Ann Residori, Mary Ann Russ, Lillian Smrekar, Theresa Smrekar, Mary Spelich, Jane Stelow, Elizabeth Sukle, Lorraine Tezak, Lillian Tadoravich, Dolores Troppe, and Pauline Wedic. (Private collection.)

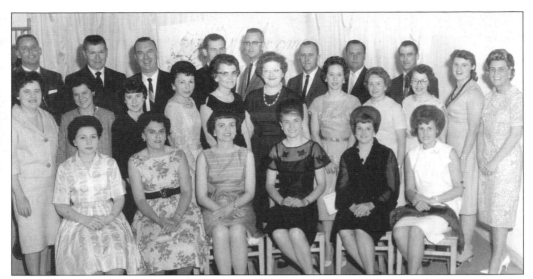

REUNION OF THE 1944 CLASS OF ST. JOSEPH CATHOLIC SCHOOL. Taken in 1964 at their 20th grade school reunion, from left to right are (first row) Lucille Gregorash, Zora Zan (née Chuck), Marie Theresa Stelow (née Culik), Rosemary Rogel (née Horvatin), Jane McNeil (née Stelow), and Dolores Bolte (née Horvatin); (second row) Mary Ann Gregorich (née Russ), Dolores Krzysciak (née Bostjancic), Dorothy Surman (née Bostjancic), Eileen Young (née Ferkal), Elizabeth Fassiotto (née Sukle), Dolores Klepec, Theresa Guenther (née Smrekar), Lillian Bennett (née Smrekar), Lorraine Slaughter (née Machak), MaryAnn Stasko (née Residori), and JoAnn Garbin (née Pirc); (third row) Walter Camp, Bernard Muren, Norman Nemanich, Robert Rogel, Anton Nemanich, John Jevitz, Joseph Wolf, and Joseph Vidmar. (Private collection.)

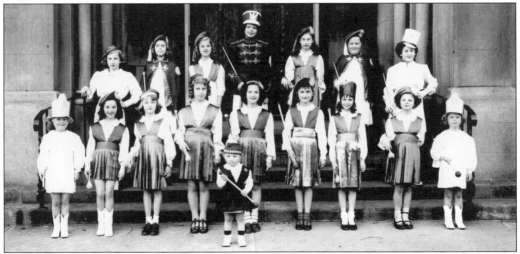

JOLIET BATON TWIRLERS OF 1949. Slovenian Women's Union Local 20 sent these baton twirlers to the national convention in Pueblo, Colorado, in 1949, and four of the girls captured honors: Mary Stoiber, Lorraine Niedlo, Marilyn Dobczyk, and Caroline Barbich. The baton twirlers are, from left to right, (first row) Vera Mae Ancel; (second row) Judy Gale, Marlene Kucera, Jerry Malimoski, Caroline Barbich, Lorraine Niedlo, Jean Muren, Joan Yanke, Joan Sienko, and Rosemary Gale; (third row) Marilyn Dobczyk, Marilyn Babich, Kathleen Rogel, Mariagnes Troutman, Eleanor Wisineski, Barbara Crnkovich and Mary Catherine Stoiber. (Courtesy of Josephine Erjavec.)

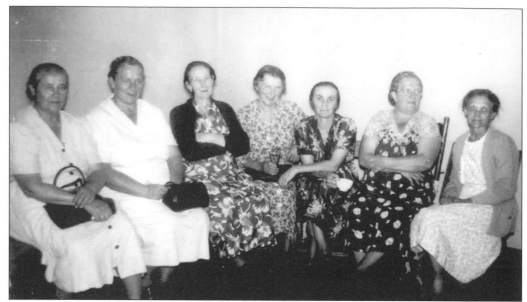

**SLOVENIAN LADIES.** This 1948 photograph was taken at a neighborhood bridal shower given for Helen Janesh before her marriage to Raymond Kezele. Pictured at the event are, from left to right, Polonia Lockner, Julia Turk, Olga Scbiel, unidentified, Mary Wolf, Ana Malker, and Rose Kapsch. (Private collection.)

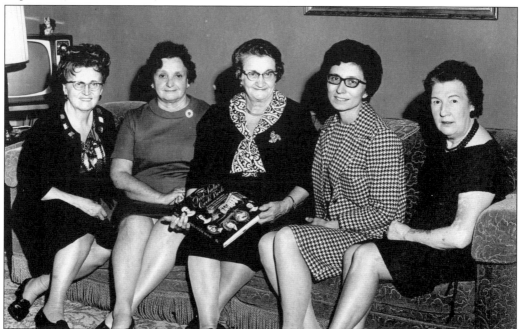

**40TH ANNIVERSARY OF THE SLOVENIAN WOMEN UNION OF AMERICA BRANCH 20.** In October 1968, from left to right, Josephine Erjavec, publicity chairman; Josephine Muster, vice president; Emma Planinsek, president; Olga Ancel, secretary; and Josephine Sumic, general chairman, planned the 40th anniversary celebration of SWU Branch 20. A mass was held at 8:45 a.m. at St. Joseph's Church followed by a breakfast in Ferdinand Hall on Clay Street. (Courtesy of Josephine Erjavec.)

# Three

# JOLIET WORKS

The Sanitary and Ship Canal and its predecessor, the Illinois and Michigan Canal, paired with intersecting railroads to launch Joliet into industrial growth of record proportions. While these industries employed thousands of workers, they were not the only means of earning a living in the city. Many men would save enough money from these industrial jobs to enable them to pursue independent businesses. Each neighborhood had its own ethnic shops, including bakeries, funeral parlors, meat markets, tailors, barbers, taverns, and shoemakers, and each played an important role in the development and vitality of the community. As the city's population grew, so too did essential services.

The official "birth" of the Joliet Fire Department is recorded in handwritten minutes of a city council meeting on December 12, 1853. The department was composed of volunteers until chief engineer Henry Rub and the Committee on Fire and Water first organized a pay scale for fire personnel in May 1876.

The *Juliet Courier* (1839) was the first newspaper in the town, and over the years it would evolve and expand into the *Joliet Signal* (1843), the *True Democrat* (1847), the *Joliet Daily Republican* (1862), the *Joliet Record* (1870), the *Joliet Sun* (1872), the *Joliet News* (1877), the *Joliet Herald* (1904), and the *Joliet Herald-News* (1915). Then, in 1915, Col. Ira C. Copley consolidated the *Joliet Herald* and the *Joliet News* creating the *Joliet Herald-News*. The paper would outgrow two locations before settling into its current headquarters at 300 Caterpillar Drive in 1974. Today it is known as *The Herald News*.

By 1936, Joliet was the center of America's wallpaper industry, with six mills employing more than 1,000 workers. Advertising for the company claimed production of up to 100 million rolls yearly.

Immediately following the start of World War II, Joliet became an extensive manufacturer of war materials. Jobs at the Joliet Arsenal caused a dramatic increase in Joliet's population, including major growth in its black community.

Joliet is in the midst of a second renaissance. Just as it did in the beginning of the 20th century, the city is experiencing residential and commercial growth. The economic backbone has shifted from labor-intensive industry to one of entertainment and recreation. A 2000 census listed the city's population at 106,221. By 2005, Joliet's population had increased to over 129,000 residents covering an area of 41 square miles.

**ADAM GROTH.** Born in 1847 in Marburg, Germany, Adam Groth studied architecture and learned the stone-cutting trade in his native country before coming to Chicago in 1871. His profession led him in 1884 to take the job as foreman for E. R. Brainard, contractor for an addition to the Illinois State Penitentiary located in Joliet. By 1895, Groth had his own stone and contracting business on East Cass Street that employed more than 100 men. He was responsible for building Joliet's Union Station, United States post office, public library, First National Bank, and the Joliet Central Township High School. In 1895, Groth was elected Joliet city treasurer. He died on December 5, 1919, while on a train trip out west with his family. Ninety-one-year-old Willa Schroeder is the granddaughter of Adam Groth, and still resides in Joliet at the Adam Groth Estate. (Courtesy of the Joliet Area Historical Museum.)

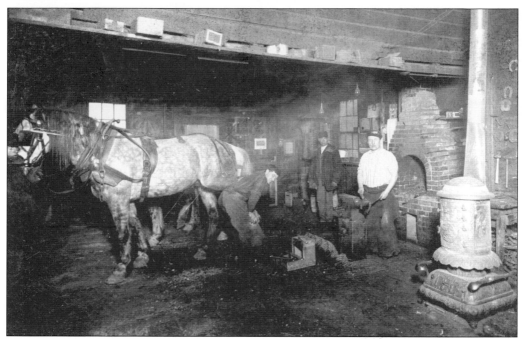

**BLACKSMITH SHOP.** Blacksmiths were vital craftsmen in Joliet. The job required both physical strength and skill to work with near molten-state iron and pound it with a hammer creating or repairing whatever tools his customer needed. This blacksmith may have purchased his horse and mule shoes from the Pheonix Horse Shoe Company. The Joliet plant was built in the early 1890s, and became a major Joliet employer, producing horseshoes for not only the national market, but for the European and South American trade as well. (Courtesy of the Joliet Area Historical Museum.)

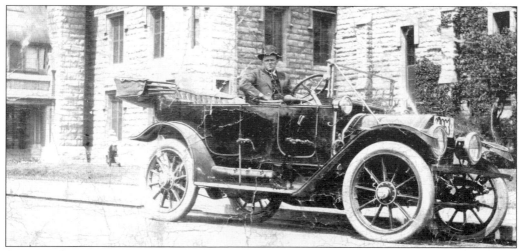

**ILLINOIS STATE PENITENTIARY OF JOLIET.** The castle-like structure of the Illinois State Penitentiary had 25-foot-high, six-foot-thick walls. The car pictured here is standing in front of the prison walls on Collins Street. Behind the wheel of his Cadillac is Anton Nemanich. Nemanich came to America in 1884, settled in Joliet, and became a local entrepreneur involved with various businesses in the area known as Slovenian Row. (Courtesy of Mardell Keenan.)

ST. JOSEPH'S HOSPITAL. The Franciscan Sisters of the Sacred Heart founded St. Joseph's Hospital in 1882. The hospital was located on 372 North Broadway Street until 1964, when the present facility was built at 333 North Madison Street on Joliet's west side. (Courtesy of the Joliet Area Historical Museum.)

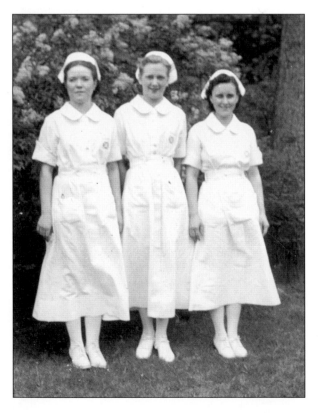

NURSES OF ST. JOSEPH HOSPITAL. On July 1, 1964, St. Joseph Hospital School of Nursing became the first day-school of nursing in the state of Illinois. (Courtesy of the Joliet Area Historical Museum.)

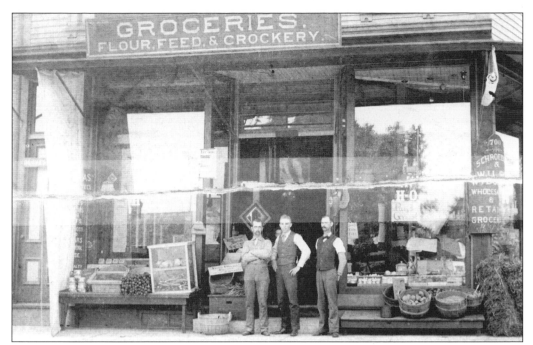

**SCHROEDER AND WILSON WHOLESALE AND RETAIL GROCERS.** In this 1891 photograph, from left to right, Sam Armagast, Ben Schroeder, and Richard Vliet stand in front of Schroeder and Wilson's, a Joliet grocer of flour, feed, and French crockery. The sign posted on the front of the store reads, "Horse and Buggy For Sale," while in the window to the right of the men the sign reads, "Dandy Fish Pole." (Courtesy of the Joliet Area Historical Museum.)

**FRED SEHRING BREWING COMPANY.** This 1916 advertisement for the Fred Sehring Brewing Company is from the 25th anniversary publication celebrating St. Joseph's Slovenian Church in Joliet. The copy notes Sehring Brewing was established in 1868 and organized in 1882. Sehring, located at Scott and Clay Streets, was the first local brewing company to install steam beer kettles in the production of beer. (Courtesy of Peter Papesh.)

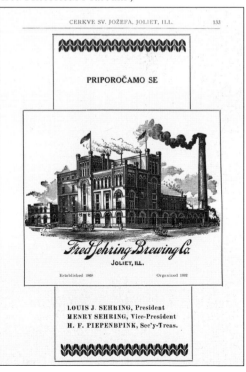

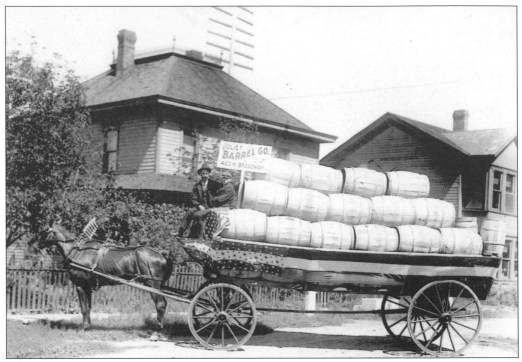

**BARREL COMPANY WAGON.** Joliet Barrel Company was located at 403 North Broadway Street. During the early 1900s, the delivery wagon and horse would be decorated with flags and participate in local parades. These unidentified delivery men were possibly headed to the Fourth of July parade in 1905. (Courtesy of the Joliet Area Historical Museum.)

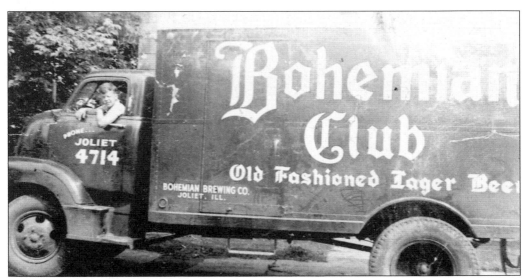

**BOHEMIAN CLUB BEER TRUCK.** Bohemian Club Beer advertised, "the finest beer made with high grade raw-products and processed to the point of best quality." Joliet Bohemian Brewing Company, located at 100–104 Collins Street, brewed and bottled old-fashioned lager beer. (Courtesy of the Joliet Area Historical Museum.)

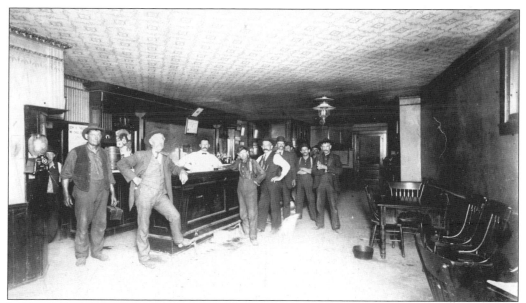

JOSEPH JAEGER SALOON. Saloons have always played an important role in the socialization of neighborhoods. In 1906, Joseph Jaeger, seen behind the bar, began operating his establishment at 429 North Broadway Street. The business prospered until 1919, when Prohibition forced the fare to change to soft drinks. Many local saloon keepers went out of business. This picture portrays Joseph Jaeger and his patrons during the saloon's heyday. (Courtesy of the Joliet Area Historical Museum.)

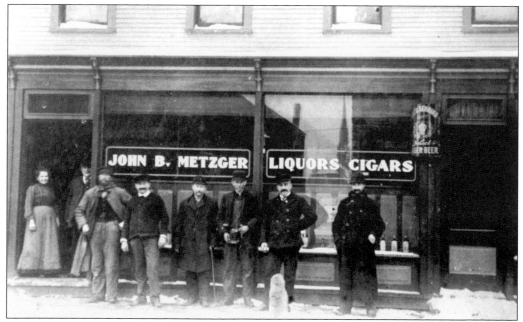

METZGER SALOON. John B. Metzger served Sehring Lager beer at his saloon in Joliet. This group of unidentified patrons braved the cold weather to pose in front of the neighborhood tavern's large windows reflecting the church spire in this undated photograph. (Courtesy of the Joliet Area Historical Museum.)

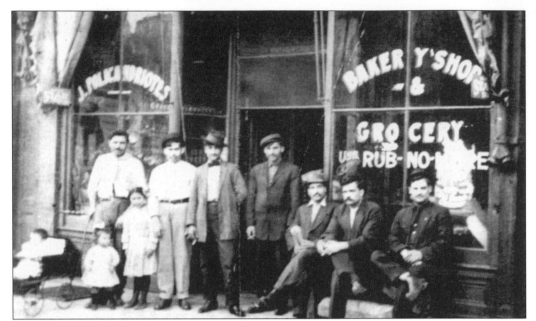

**J. POLICANDRIOTES.** This picture was taken in front of J. Policandriotes Bakery Shop and Grocery located on Bluff Street in 1913. Standing from left to right are George, William, James (the owner of the store), and John Policandriotes. The three gentlemen seated are, from left to right, unidentified, John Honiotes, and unidentified. The three Policandriotes children in the picture are, from left to right, John in the buggy, Irene, and Angelina. George Policandriotes was the first vegetable grower from Greece to locate in this area. (Courtesy of Vange Wolf.)

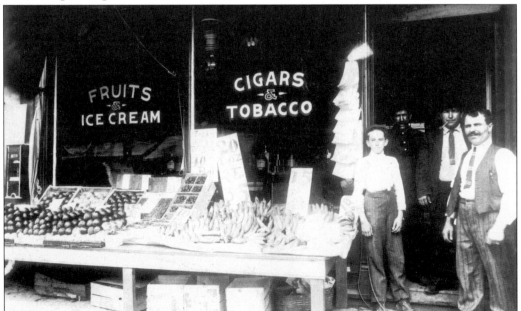

**GREEK GROCER.** James Policandriotes had a second grocery store located at Bluff and Jefferson Streets. Policandriotes is on the right, and the other three men in the picture are unidentified. By 1916, there were more than 300 Greeks in the area. They founded All Saints Greek Orthodox Church the same year. (Courtesy of Vange Wolf.)

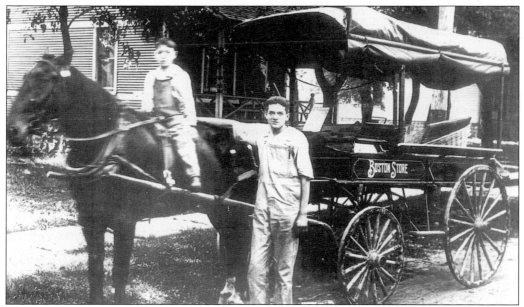

**Boston Store Delivery Wagon.** Russian immigrant M. A. Felman came to Joliet in 1889. With less than $200 in capital and the support of the president of James A. Farwell Dry Goods Company of Chicago, he opened the Boston Store. By 1918, the store had grown, at Jefferson and Ottawa Streets, from its original 785 square feet and two employees to 165,000 square feet and 165 salespeople, where the policy of "good service and high quality" was followed by the entire staff. Pictured here are two unidentified delivery boys with the store wagon around 1900. (Courtesy of the Joliet Area Historical Museum.)

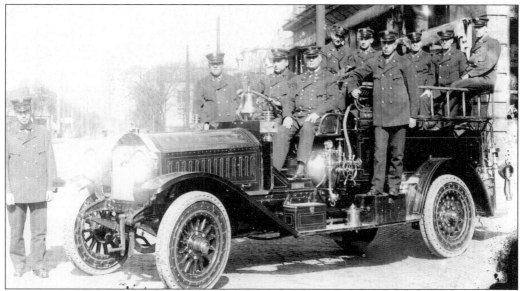

**Early Joliet Fire Department Truck.** Joliet firemen pose on a newly acquired Robinson Fire Apparatus Company truck (around 1915 or 1916) in front of old fire station No. 1. Fire Marshall Calvin Royce chronicled, in fire department journals, the modernization from horses to machines with the purchase of combination chemical and hose wagons. This view looks north on Ottawa Street from Clinton Street. (Courtesy of the Joliet Area Historical Museum.)

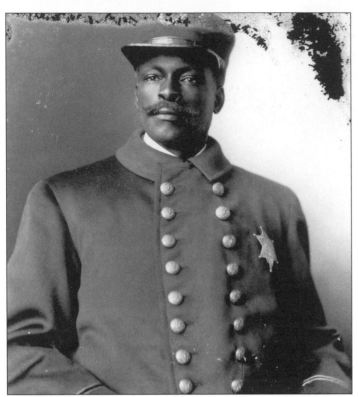

**BLACK POLICE OFFICER.**
It was during the tenure of Mayor John Dean Paige that he appointed Officer Hamlet, the black police officer pictured here, to serve in the police department during the late 1880s. According to the *Brown Book* published in 1959 by Chastine C. Mason, Officer William Foster, in 1853, was the first African American policeman to be connected with the Joliet Police Department. (Courtesy of the Joliet Area Historical Museum.)

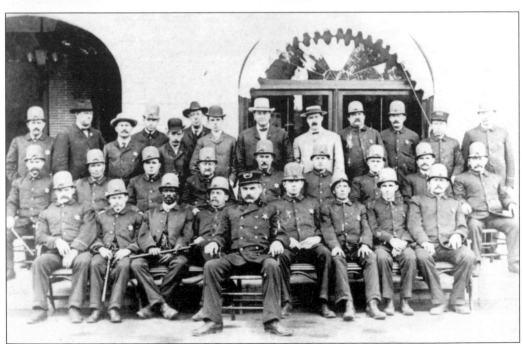

**JOLIET POLICE DEPARTMENT.** Chief Charles F. Blood, first row center, is shown along with the men of Joliet's Police Department in this 1888 photograph. (Courtesy of the Joliet Area Historical Museum.)

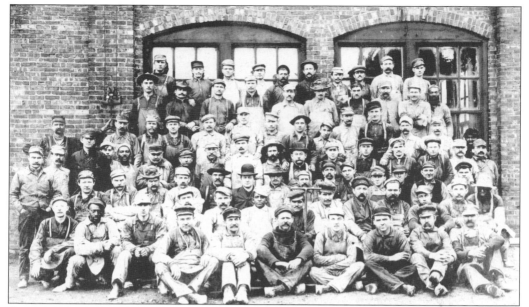

ROCKDALE STEEL WORKS, 1898. Steel mills were the strength of the local economy by 1898. These workers of the Rockdale steel works plant represent the changing faces of the growing local population as eastern European immigrants and African Americans came to fill the job opportunities the mills created. The work was hard, and safety concerns were always an issue. Monthly mill publications were written and circulated to workers by workers, warning employees of the special hazards of handling "molten metals, hot liquids, or dangerous substances of any kind." (Courtesy of the Joliet Area Historical Museum.)

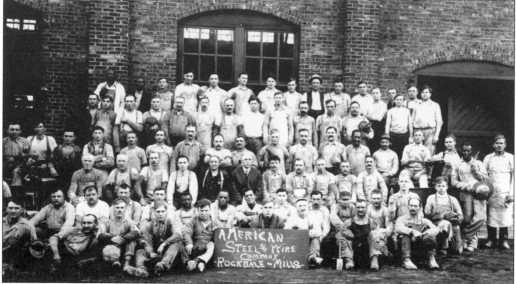

AMERICAN STEEL AND WIRE COMPANY ROCKDALE MILLS. The hard-working men of the Rockdale steel mill are pictured in this 1916 photograph. Especially noteworthy is the footwear of the men in the first row. Special foundry shoes or ones with low, broad heels and stout soles are worn. When worn with protective "leggings made of asbestos or chrome leather," these shoes resisted heat and "hot substance from reaching the flesh." (Courtesy of the Joliet Area Historical Museum.)

**STANDARD OIL.** The Standard Oil building was located at 1001 Cass Street. Standard Oil was one of the most popular producers of gasoline and kerosene in the United States in 1900. (Courtesy of the Joliet Area Historical Museum.)

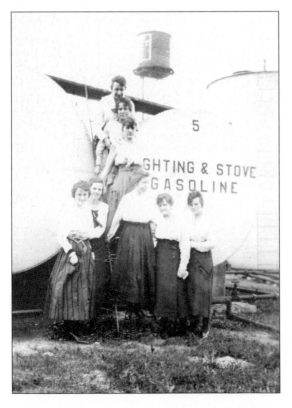

**STANDARD OIL EMPLOYEES.** Unidentified Standard Oil office workers posed in front of lighting and stove gasoline tanks in this *c.* 1910 photograph. (Courtesy of the Joliet Area Historical Museum.)

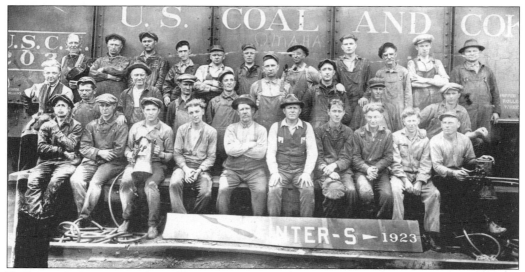

**E. J. AND E. PAINTERS.** Elgin, Joliet and Eastern Railway Company trains were some of the most colorful rail lines in the nation. Boxcars, gondolas, flat cars, and hoppers were painted in the East Joliet yards by the men in this 1923 photograph. The painting process would require scraping off the old paint, which could take up to 32 hours, before applying primer, paint, and brushed-by-hand stenciled insignias and trim. Each boxcar required 25 gallons of paint, 14 gallons for a gondola, 18 gallons for a hopper, and 12 gallons for a flatcar. (Courtesy of Aloysius Getson.)

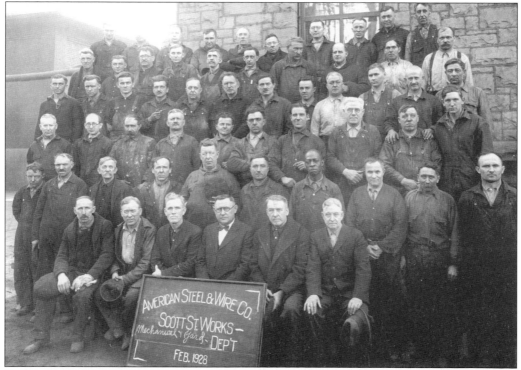

**SCOTT STREET WORKS.** The employees of the American Steel and Wire Company Mechanical and Yard Department are pictured in this February 1928 photograph. (Courtesy of the Joliet Area Historical Museum.)

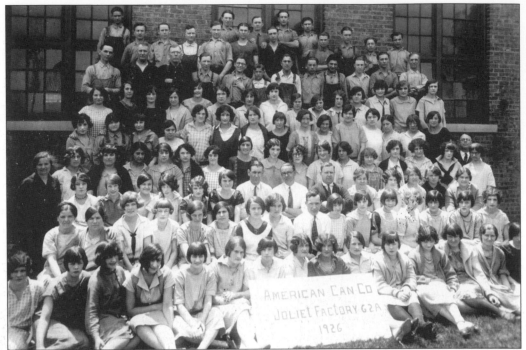

**AMERICAN CAN COMPANY.** American Can Company advertisements declared, "The world's largest makers of tin containers; vacuum can for coffee, refinery-sealed can for motor oil and the keglined can for beer." Hungarian immigrant Helen Mosolygo, located in the third row to the left in dark dress, is pictured with her co-workers at the Joliet Factory of the American Can Company in this 1926 photograph. The can company was one of the few places in the 1920s were a woman could seek employment outside the home. (Courtesy of Carol Mosolygo.)

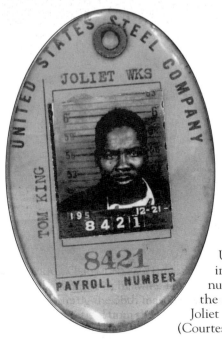

**UNITED STATES STEEL COMPANY PAYROLL IDENTIFICATION.** Tom King went to work for the United States Steel Company after moving to Joliet in the 1940s. King's steel mill identification and payroll number are shown here. After years of employment in the steel works, King established King's Disposal, servicing Joliet and Lockport areas between the 1950s and early 1970s. (Courtesy of Joseph Baines Jr..)

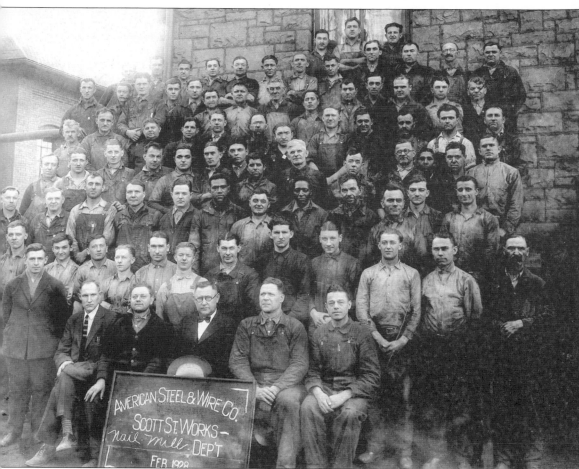

**AMERICAN STEEL WORKERS.** Austrian native Louis Lukancic spent three months traveling on the Atlantic Ocean aboard the *San Giusto*, a ship originally known as the *Furst Bismarck*, built in 1890 by "Vulcan" in Stettin, Germany. It became an immigrant carrier between Trieste and New York in its final years. Lukancic arrived in New York on March 13, 1921. He traveled by train to Illinois and found work as a nail machine operator at the American Steel and Wire Company in Joliet, where he worked for nearly 40 years until his death at age 63. Lukancic (top row far left) and Rudy Silc (standing directly in front of him) are the only two men identified in this February 1928 picture of the American Steel and Wire Company Scott Street Works Nail Mill Department. (Courtesy of Angela Zaida.)

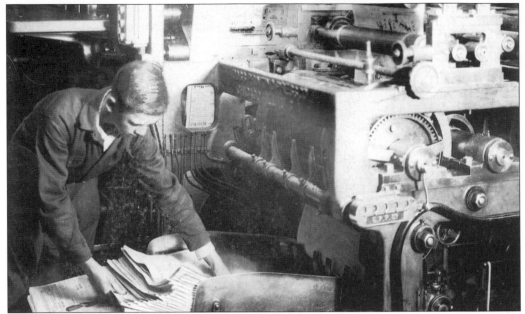

**JOLIET HERALD-NEWS.** A young Joseph R. Trizna is pictured here at work in the print shop of the *Joliet Herald News* around 1923. The newspaper was located at the southwest corner of Scott and Van Buren Streets until outgrowing its downtown facility in 1975. Today a parking lot stands at the corner. Trizna would grow up to become police chief of Joliet from 1956 to 1962. (Courtesy of the Joliet Area Historical Museum.)

**MICHAEL A. KRAUSE.** Michael Krause, a 1918 graduate of Joliet Township High School, worked as a machine apprentice with the Elgin, Joliet and Eastern Railway Company in January 1917, at the pay rate of $1.75 per day, and received a $100 bonus at the expiration of his contract. Krause later worked for the Federal Match Corporation. (Courtesy of the Joliet Area Historical Museum.)

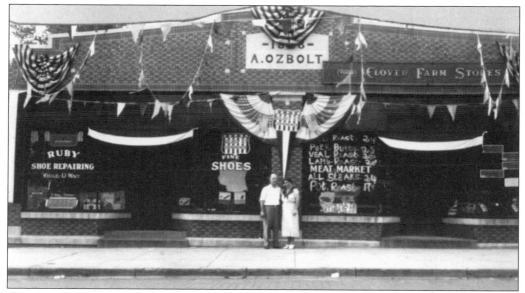

OZBOLT SHOE SHOP. Anton and Josephine Ozbolt owned and operated the shoe repair shop shown in this 1928 photograph at 256 Ruby Street. A good friend to everyone in the neighborhood, the Ozbolts ran the shop until the Great Depression forced their many customers to run up lines of credit. Like many other small business owners unable to collect unpaid tabs, the couple was forced to close the store. In better times, they opened another shop across the street. (Courtesy of St. Mary Nativity Church.)

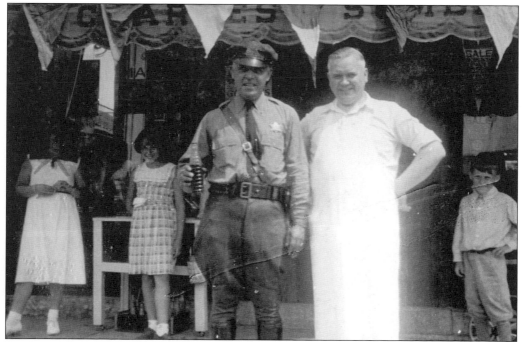

SUMBAUM STORE. Charles Sumbaum was the proprietor of the Sumbaum Store at 311 Ruby Street. The local grocer is shown in this photograph with an unidentified Joliet motorcycle cop enjoying a soda break. (Courtesy of the Joliet Area Historical Museum.)

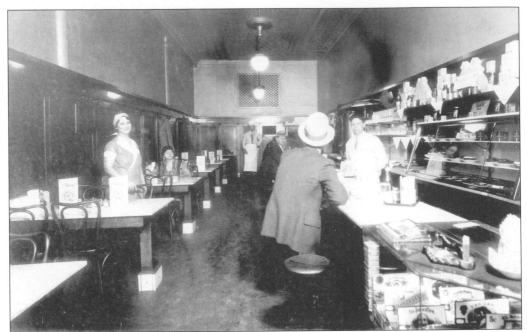

**ORPHEUM RESTAURANT.** This photograph shows the inside of the Orpheum Restaurant on Cass Street in the 1930s. It was owned and operated by Greek immigrant Thomas Kokas. Kokas was one of 50 charter members of the Myconos Society of Joliet, formed in 1926 by a group of Greek men who wished to continue their ties with their former homeland. (Courtesy of Vange Wolf.)

**NEIGHBORHOOD FAMILY GROCERY.** Before the era of big food warehouses, every neighborhood had a corner grocery store. The Planinsek Grocery and Meat Market was one such place, located at 1314 Elizabeth Street (the corner of Russell and Elizabeth Streets). Owner, Martin Planinsek (far right) operated the shop along with his wife, Emma. Ludmilla and John Yuvan, sister and brother-in-law of Emma, are also pictured along with the children of the two families. (Courtesy of Angela Zaida.)

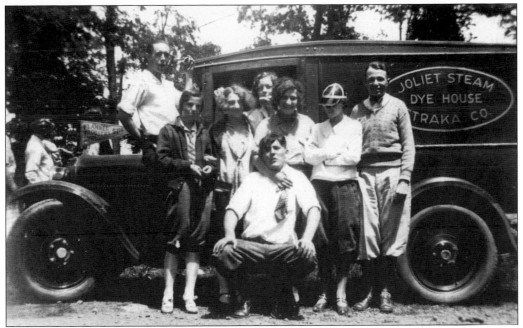

**STRAKA'S JOLIET STEAM AND DYE HOUSE.** In the 1930s, Bernard Neumark was the proprietor of Straka's Joliet Steam and Dye House Company, located at 652–654 Cass Street. The company advertised chemically cleaned and pressed garments, including curtains, dresses, plumes, gloves, and gentlemen's attire. By 1957, Straka's Joliet Dyers and Cleaners had branch offices at 13 North Reed Street, 400 Western Avenue, 1210 Theodore Street, and 218 Cass Street. Louis Moroni was the proprietor. (Private Collection.)

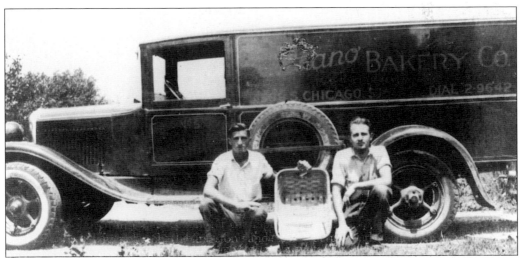

**MILANO BAKERY TRUCK.** During the 1930s, Milano Bakery was located at 599 South Chicago Street. These two deliverymen show off their breadbasket and company truck. Today the DeBenedetti family still carries on the family tradition at 427 South Chicago Street. (Courtesy of the Joliet Area Historical Museum.)

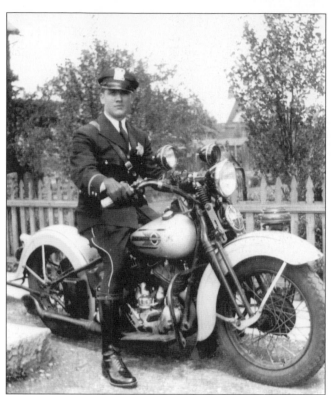

**JOSEPH R. TRINZA.** Joseph R. Trinza, born and raised in Joliet, entered the Joliet Police Department in the late 1930s. He first served the city as a beat cop, and shown here, as a motorcycle cop, before advancing to sergeant, captain, and finally chief of police from 1956 to 1962. (Courtesy of the Joliet Area Historical Museum.)

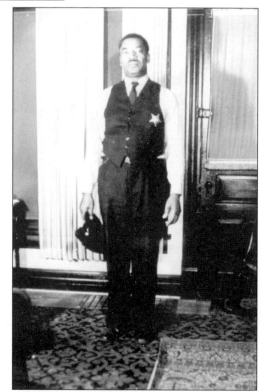

**SHERMAN DAVIS.** Officer Sherman Davis, shown here in his uniform, served as a Joliet policeman. (Courtesy of the Joliet Area Historical Museum.)

**DEPUTY SHERIFFS.** Thomas Kokas served as deputy sheriff of Will County from 1932 to 1936. During that time, Kokas, pictured here on the left with Deputy Sheriff Thomas Wise, worked under Sheriff Michael Breen. Kokas also served as the Circuit Court bailiff during the Angelo Audi murder trial; the trial of John Hritz, charged with the slaying of Phillip Zappa; and the investigation of the fatal razor slashing of Richard Loeb at Stateville prison, all high-profile trials of the time. (Courtesy of Vange Wolf.)

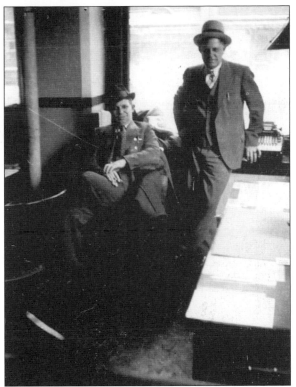

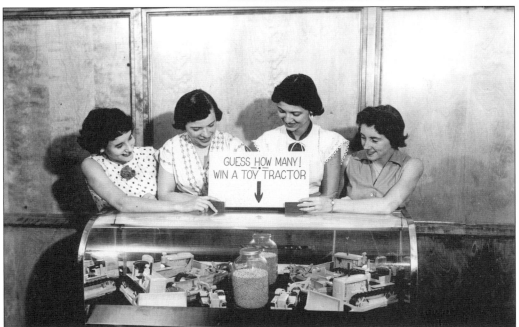

**CATERPILLAR ACCOUNTING DEPARTMENT.** Pictured here are four female employees of Caterpillar's Joliet Accounting Department as they attempted to figure out how many BB's were in a sealed jar during the Pageant of Progress on July 1, 1954. From left to right are Joan Taylor, Kay Lorenc, Vange Kokas, and Helen Hayes. (Courtesy of Vange Wolf.)

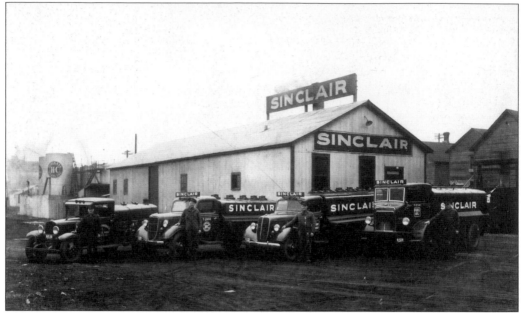

**SINCLAIR REFINING COMPANY.** Sinclair Oil Trucks are lined up with their drivers. Lawrence Offerman is second from the left; the three other drivers are unidentified. The Sinclair Refining Company was located at 214 Columbia Street during the 1930s. It moved to 66 Columbia Street in 1946, and 800 Railroad Street in 1956. Sinclair provided gasoline, motor fuel, diesel oils, and home fuel. (Courtesy of Richard and Theresa Offerman.)

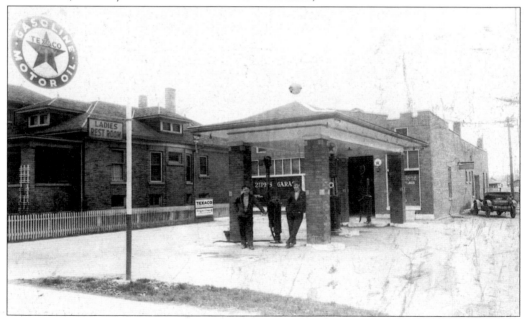

**ZIPP'S GARAGE AND TEXACO STATION.** Zipp's Garage and Texaco Dealership stood at the southwest corner of Shelby and South Chicago Streets. George Leimbacher (right) and William Rogers are pictured at the pumps of the station owned by the Zipp family who lived in the duplex next door. The construction of Interstate 80 in the mid-1960s replaced the site. (Courtesy of the Joliet Area Historical Museum.)

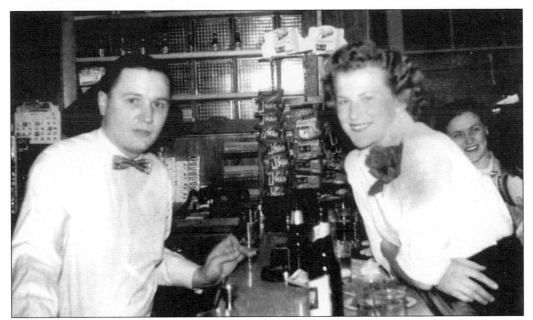

**WOLF'S TAVERN.** Wolf's Tavern, located at 507 Theodore Street for more than 25 years, was the kind of neighborhood place where a man could bring his family, order a soda pop for the kids, play a record on the jukebox for a dime, and dance with his wife. This picture of proprietor Joseph Wolf, and Cecilia, his wife, was taken in 1956, shortly after the bar's opening. (Private collection.)

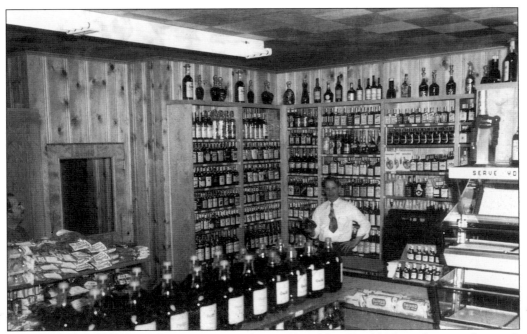

**UNION PACKAGE LIQUOR STORE.** On April 1, 1955, a *Joliet Herald News* photographer took this photograph of Thomas Kokas, surrounded by walls stocked with liquor and groceries inside the Union Tavern and Package Liquor Store, located at Bluff and Jefferson Streets. Kokas and George Contos were the proprietors. (Courtesy of The Herald News.)

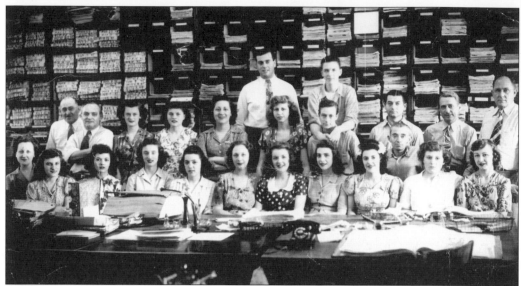

**EJ&E RAILROAD OFFICE WORKERS.** The EJ&E Railroad Office was located above the Ford Hopkins Drug Store on Chicago Street. This 1944 or 1945 photograph includes Mildred Radakovich, Yolanda Moroni, Virginia McCarthy, Anthony Molica, Earl A. Liebtenaure of World Insurance Company, Gertrude Czickan, Jean Delaney, Marie E. Kastelie, Jesse Ackerman, Ann Ramuta, Betty Scully, M. J. Beaudry, Lois Cardwell, Elma O'Reinge, Luke Boynton, Edward Pavlik, and ? Tormento. Richard "Dick" Offerman is standing in the last row, on the right. (Courtesy of Richard and Theresa Offerman.)

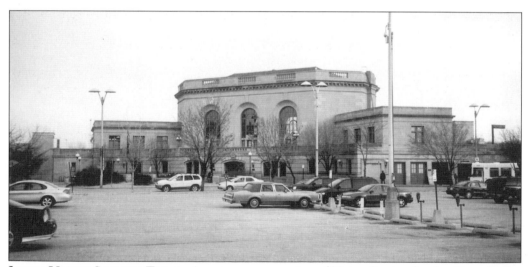

**JOLIET UNION STATION TODAY.** A two-year renovation of Union Station by the City of Joliet began in 1989, and on October 19, 1991, 79 years after the first Union Station dedication ceremony, Lt. Gen. Jerome B. Hilmes, Office of the Secretary of the Army, gave a keynote address during the restoration and rededication ceremony of Joliet Union Station. (Private collection.)

# *Four*

# SCHOOL DAYS

Joliet's first high school was established in 1880. Located at the northeast corner of Chicago and Webster Streets, the school had five faculty members and 200 students. Nineteen years later, the Joliet Township High School District was formed and J. Stanley Brown was named its first superintendent. Within a year, construction began on a new public high school located in the city's downtown area, and in 1901, the building was dedicated. At the same time, Brown along with William Rainey Harper, president of the University of Chicago, secured plans to begin post-graduate studies for students at the same facility and Joliet Junior College, the first public junior college in the United States, would begin with six students. The first two African American teachers employed by the Joliet Public Schools were Juanita Kinder and Ina M. Varnado, in September 1954.

By the 1960s, overcrowding conditions would require the district to build additional high schools on both the east and west sides of Joliet. While the Joliet East campus has since been sold, Joliet West continues to grow and expand its campus on the southwest corner of Larkin and Glenwood Avenues.

Construction of Joliet's first parochial coeducational high school, Providence High School, was completed in 1962. Built on the south side of U.S. Route 30, the facility sits east of Gougar Road in New Lenox. The school began in 1880 under the name St. Mary Academy in Joliet, run by sisters known as the Ladies of Loretto. In 1985, the Order of St. Augustine took over operations and the name was changed to Providence Catholic High School. Providence celebrated its 75th anniversary in the Diocese of Joliet in 1993.

De La Salle High School opened its doors to 45 young men in 1918, and in 1933, the Carmelites purchased the high school and renamed it Joliet Catholic High School. After 121 years as a catholic school for girls at three different locations, St. Francis Academy consolidated with Joliet Catholic High, becoming Joliet Catholic Academy, located at 1200 North Larkin on Joliet's west side.

Today, Joliet Central, Joliet West, Providence, and Joliet Catholic Academy have a combined student population of more than 6,200.

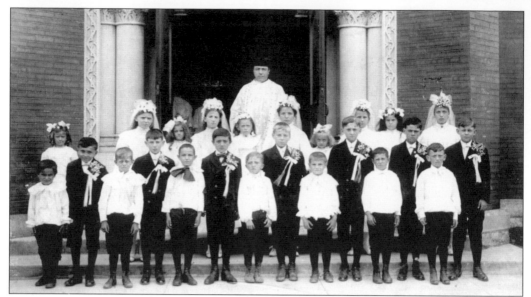

**ST. MARY CROATIAN CHURCH FIRST COMMUNION CLASS, 1908.** When the Hansen and Peterson company completed the red brick building at 706 North Broadway Street in 1908, the 110 parishioners were residents of Joliet, Lockport, Rockdale, Romeoville, and Lemont. On June 28 of that year, students of the parish school made their First Communion. Pictured from left to right are (first row) John Rudman, Anton Sila, Frank Kezerle, Tom Koludrovich, Steven Racki, Joseph Racki, two Liker brothers, unidentified, Joseph Mikan, Anthony Fritz, Laurence Zema, Peter Koludrovich, and Rudolph Kezerle; (second row) Ann Kezerle, Ann Masat, Mary Kirincich, Mayme Peer, Agnes Juricich, unidentified, Sophie Bajt, ? Bozich, unidentified, and Helen Bajt; (third row) Fr. George Violich. (Courtesy of St. Mary Nativity Church.)

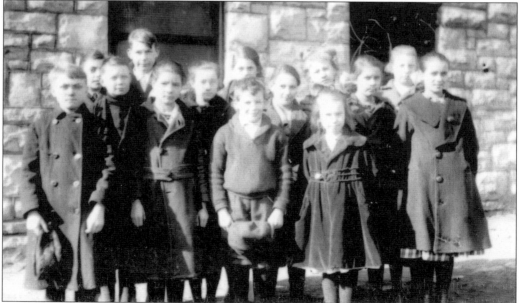

**HENDERSON AVENUE SCHOOL.** Taken on January 27, 1921, this photograph shows the children of the eighth-grade "B" class of Henderson Avenue School. (Courtesy of the Joliet Area Historical Museum.)

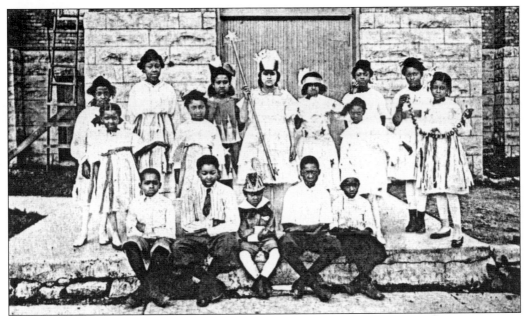

**SECOND BAPTIST JUNIOR MEMBERS.** In this *c.* 1920 photograph, the children of the Second Baptist Church Sunday School are dressed in costumes, possibly for a play performed before family and friends. That same year, the congregation had paid off the mortgage, and the church was free from debt. Second Baptist is the oldest African American church in Joliet. (Courtesy of Second Baptist Church.)

**RIDGEWOOD SCHOOL.** In 1929, Bertha Hurd was the principal of the Ridgewood School located at the northwest corner of Walnut and Jackson Streets. This photograph captures the happy expressions of some of the students that year. (Courtesy of the Joliet Area Historical Museum.)

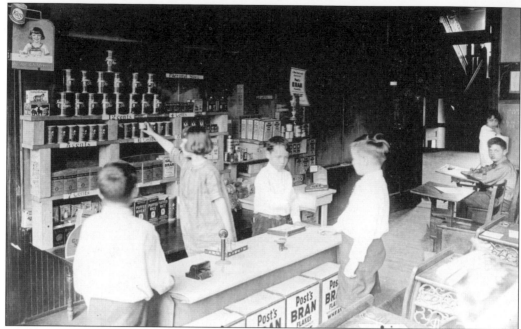

**THIRD GRADE FARRAGUT STORE.** School-day lessons often imitated real life, as captured in this 1924 photograph of third graders at Farragut School. A mock grocery store was set up in the classroom, and students played the roles of grocer, stock boy, and customers. Students sold a can of coffee for 12¢, Grape Nuts for 7¢, and a box of Kellogg's Bran for 6¢. Their shelves were stocked full of goods that included Argo Starch, Quaker Puffed Rice, Puffed Wheat, Post's Bran Flakes, cocoa, salt, and Karo syrup. (Courtesy of the Joliet Area Historical Museum.)

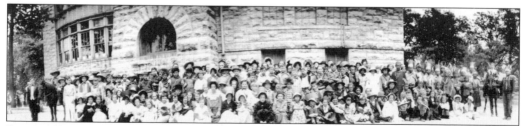

**PIONEER DAY.** Woodland School students looked forward to Pioneer Day in May 1936. The school held one-act plays, and the children dressed up to imitate pioneers from the past. Here students show off their costumes. The school was located at Whitley and Rowell Avenues. (Courtesy of the Joliet Area Historical Museum.)

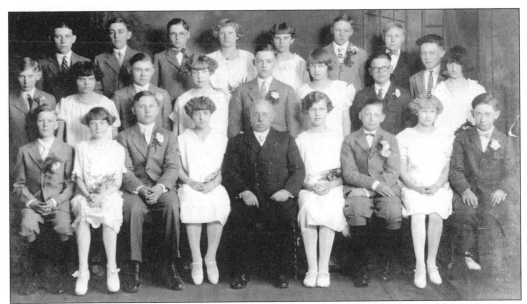

**CONFIRMATION CLASS.** This confirmation class picture at St. John English Church on Herkimer Street includes Lois Delander (second row, third from right), who grew up to be crowned Miss America. This photograph includes, from left to right, (first row) Russell Seaman, Theoda Aberhardt, Russell Inglehart, ? Kelley, Reverend Heillman, Briela Green, Claude ?, Norma Delander, and Russell Milleran; (second row) Henry Sing, Louise ?, Russell Wunderlich, Lois Kreigher, Ivan Sippel, Lois Delander, Leonard Meyer, and Lois Yahnke; (third row) Vernon McCann, Ralph Ingerman, Eugene Koenig, Oneta Seeman, Bernice Ristau, Fredrick Wiseman, Clifford Stand, and Gordon Longley. (Courtesy of the Joliet Area Historical Museum.)

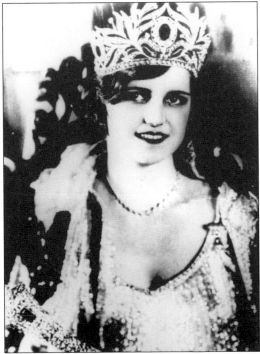

**MISS AMERICA 1927.** In 1927, Joliet's Lois Delander was a sophomore at Joliet Township High School when her ballet teacher convinced her to enter the Miss Joliet pageant at the Rialto Theater. At 16, she would become the youngest and first contestant from Illinois to be crowned Miss America by Eddie Dowling, better known as "King Neptune," on the Million Dollar Pier at Atlantic City. (Courtesy of the Joliet Area Historical Museum.)

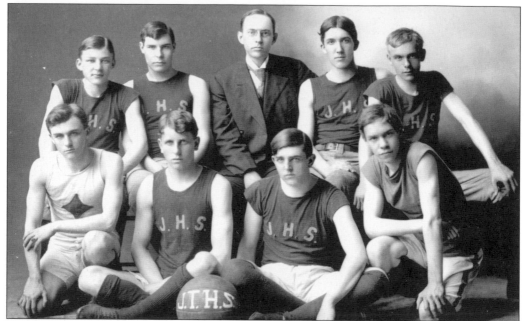

**Joliet High School Basketball Team.** Members of the Joliet Township High School basketball team pose for this team picture in 1907. (Courtesy of the Joliet Area Historical Museum.)

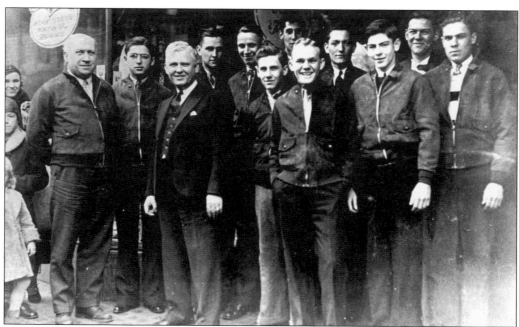

**Joliet Catholic High School Champion Basketball Team.** In 1934, Joliet Catholic defeated Stockton, California, St. Mary's to win the school's third National Interscholastic Basketball Championship held at Loyola University. Following the win, the team members received new jackets at Kline's Department Store. The starting team included Eugene Tezak (forward), Art Simon (forward), "Sketch" McGann (center), Thomas Comerford (guard), and Ed Matasenic (guard). (Courtesy of the Joliet Area Historical Museum.)

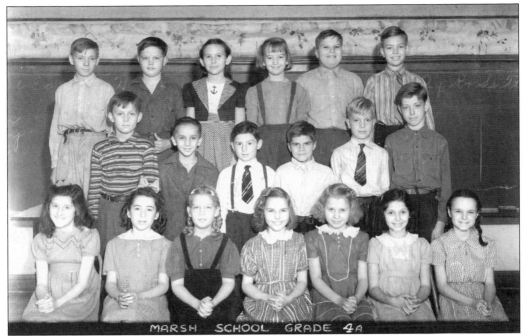

**MARSH SCHOOL STUDENTS.** Everyone looks to the camera as this 1941 photograph shows the smiling students in the fourth-grade class of Joliet's F. E. Marsh School. (Courtesy of Vange Wolf.)

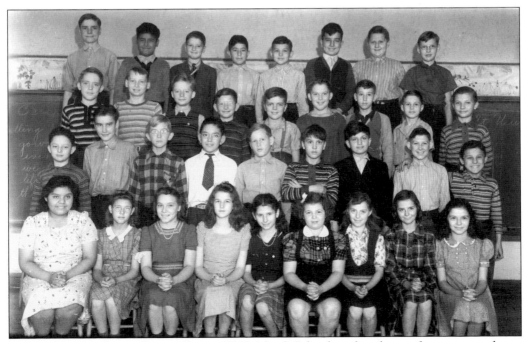

**MARSH SCHOOL SIXTH GRADE CLASS, 1941.** Marsh School produced many fine young students. Here smiling sixth graders pose for their class picture. (Courtesy of Vange Wolf.)

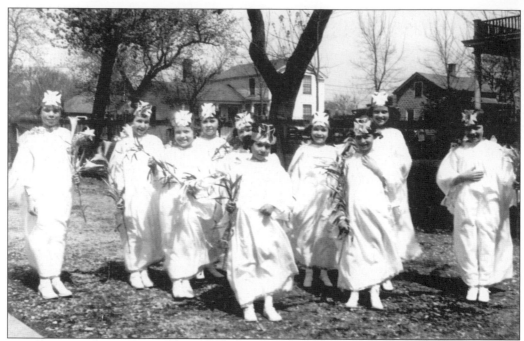

**ST. MARY NATIVITY FIRST GRADE.** St. Mary Nativity School first graders line up dressed as "angels" to lead the procession of the First Communion Class into church. (Private collection.)

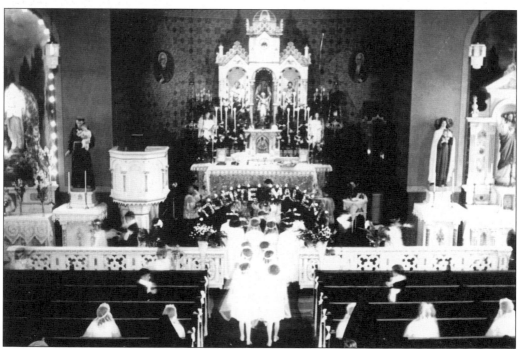

**FIRST COMMUNION DAY.** Second-grade students attired in their white dresses and dark suits comprise the first communion class as the procession marches inside the church and under the communion arch. *Djeite Maleni*, or "little children," is spelled out in Croatian across the arch. (Private collection.)

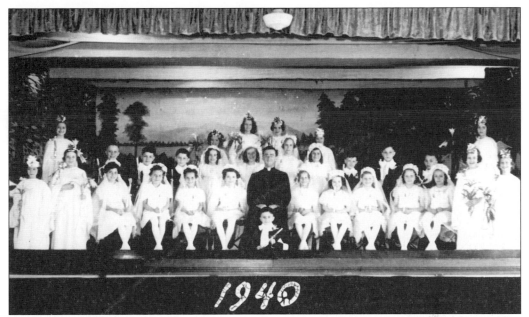

1940

**PASTOR ALOYSIUS SINSKY WITH THE SECOND-GRADE CLASS.** With happy smiles, the children pose on stage in the school hall with Rev. Aloysius Sinsky, pastor of the parish. (Private collection.)

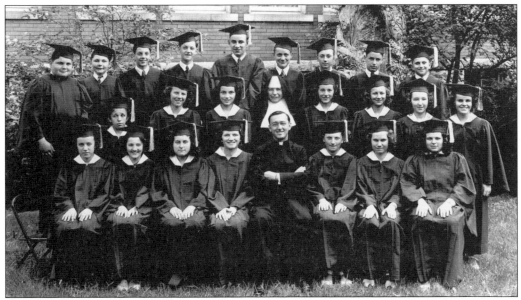

**GRADUATING CLASS OF ST. MARY NATIVITY GRADE SCHOOL.** These happy smiles belong to the 1945 graduating class of St. Mary Nativity Grade School. The students on the lawn of the school from are, left to right, (first row) Lucille Pruss, Eileen Cox, Katherine Brozevich, Rose Stiglich, Father Aloysius Sinsky, Theresa Gregorich, Lois Chorak, and Marie Bubica; (second row) Josephine Mance, Gertrude Juricic, Lorraine Pavlich, Sister Alvernia, Pauline Svetleich, Helen Grachen, Barbara Putrich, and Rosemary Borio; (third row) Anthony Today, Stephan Racki, Jack Rakar, Edward Lockner, Louis Pavich, Raymond Janes, John Plese, Joseph Garbin, and Louis Ivezich. (Courtesy of Edward Mance.)

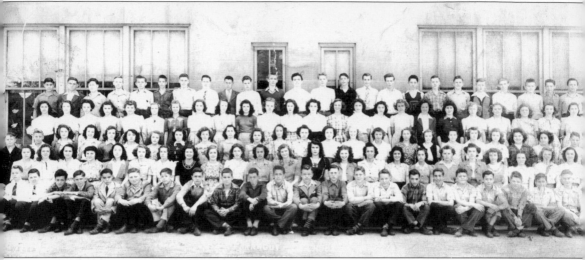

**FARRAGUT SCHOOL.** The 1945 graduates at Farragut came together for a class picture. Farragut was among 11 Joliet city schools at the time. Those idenified here are Lois Gustafson, Sylvia Randolph, Bill Kozar, Bev Davy, Norm Swanson, Jim Policandriotes, Marcia Larson, Emita Orr, Zelda Brayton, Bonnie McCollium, Betty Anne Heck, Shirley DeGrace, Betty Jane Harrison, Carol Stassen, Jane Jaksetich, Joe Plese, Richard Mutz, Jerry Lewis, Jack Prehn, Mary Petropolis, Demetra Calamaras, Jacquelyn Eich, Alberta Griffin, Beatrice A. Van Denburgh, Margaret Nicol, Nancy Slack, Norma Jean Hutton, June Carol Newman, Bernadine Vranicar, Jean Petransky, Jimmy Mackey, Jim Harman, Gene Getson, Louis Belom, James Hartley, Mike Stoyan, Jack Wilson, Gus Levaris, Louis Xigogianis, David Wells, Edward Hall, Dick Schoch, Rudy Skul, Margaret Wunderlich, Ken Gudgeon, Elizabeth Brown, Jerry Dodds, Jim Ruddy, Phyllis Moon, Peter Bates, Gene Lingholm, John Colern, Charles Fagan, and Cecilia Gečan. (Private collection.)

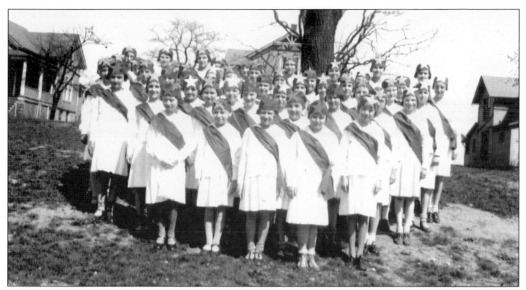

**WOODLAND SCHOOL.** Members of the Woodland School participated in the Joliet-Will County Pageant of Progress during the summer of 1955. Thousands of area residents attended the exposition of local industry, commerce, and agriculture held at Joliet's Memorial Stadium. (Courtesy of the Joliet Area Historical Museum.)

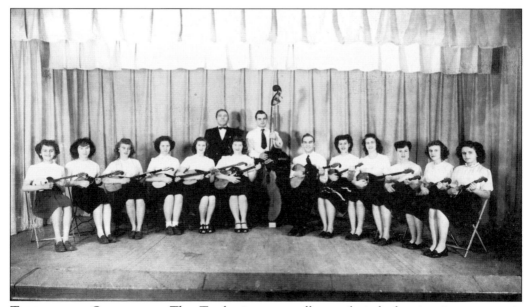

**TAMBURITZA ORCHESTRA.** The Tamburitza, or mellow, soft-pitched string instrument, is recognized as the household instrument of Croatians and is one of the oldest stringed instruments known to Christians. The 13 members of the original 1944–1945 student orchestra included Barbara Putrich, Cecilia Gečan, Emily Rigal, Rosemary Stiglic, Roseann Paskavan, Robert Kurpan, John Stiglic, Delores Paskavan, William Stiglic, Delores Naidan, Marie Glad, and their instructor, ? Roseguy. (Private collection.)

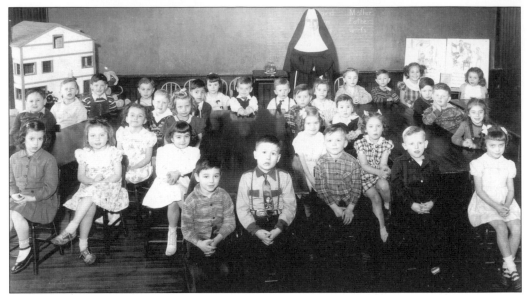

**KINDERGARTEN CLASS FEBRUARY 1949.** St. Mary Nativity School has provided Catholic education for children in preschool through eighth grade since 1906. Sister Josephine taught the class, which included, from left to right, Joseph Gabriel, Raymond Podobnik, Jack Neiden, and Anthony Nemgar, the four little boys seated in the first row of this February 1949 kindergarten class. (Courtesy of Bernadine "Bunny" Kotlar.)

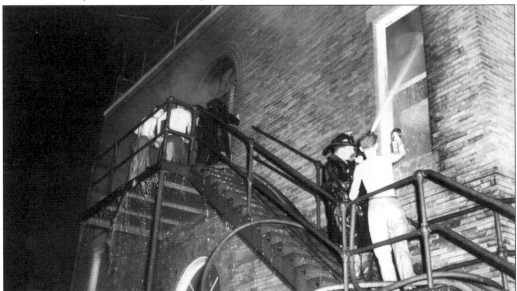

**TRAGEDY STRIKES AT LOCAL GRADE SCHOOL.** Sister M. Agnes, the principal of St. Mary Nativity Grade School in 1954, recalled, "Sometime before midnight on June 25 a fire broke out in the school basement. A neighbor who couldn't sleep because of the hot weather went out for air and saw flames in the building." That neighbor called the Joliet Fire Department and tried to alert the sisters living in the convent apartment inside the school. In the meantime, the sisters detected smoke, threw their robes over their heads to exit the flames, and were able to flee the blaze via the north fire escape. Firemen in this photograph are on the same fire escape working the flames. (Courtesy of St. Mary Nativity.)

**FIRE CHIEF ASSESSES THE DAMAGE.** Assistant Fire Chief William O'Hare (left) surveys the damage to the sisters' quarters. Parishioner Eugene Dolasin (center) and Rev. Benjamin Uzdavinis, assistant pastor (right), shine flashlights on the destruction. (Courtesy of St. Mary Nativity.)

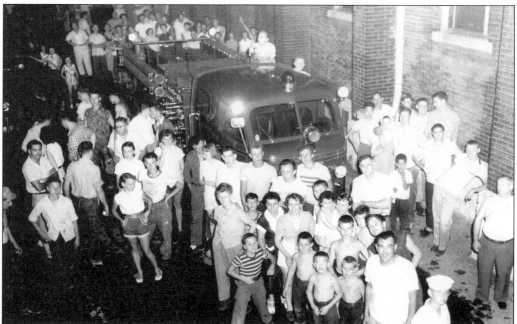

**NEIGHBORHOOD RESIDENTS CROWD THE SCENE.** In this view from the top of the fire escape on the north side of the school, the entire neighborhood is out to watch firefighters battle the blaze. The wall behind the crowd is the south side of the church. Today the Nativity Meeting Room replaces this driveway. (Courtesy of St. Mary Nativity.)

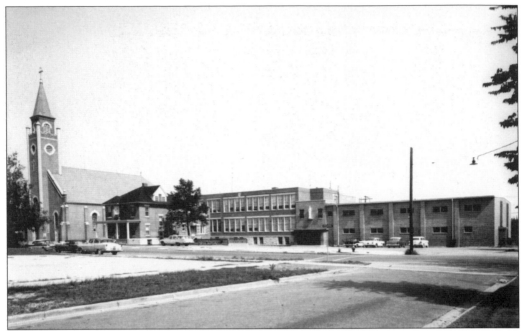

**A NEW SCHOOL RISES FROM THE ASHES.** Immediately repairs began on the damaged school, classrooms were renovated, and a new gymnasium was built at a cost nearing $60,000. Pictured here is the renovated school with the new gymnasium addition. (Courtesy of St. Mary Nativity.)

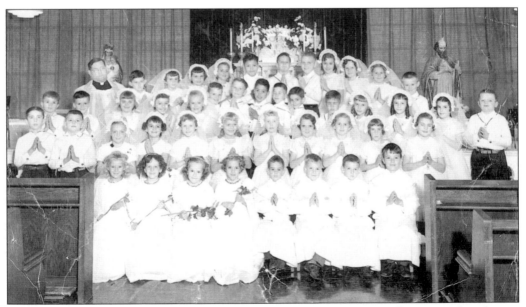

**ST. JUDE CHURCH FIRST COMMUNION CLASS OF 1955.** Rev. Peter Seidl is pictured in the top row, on the left, of this 1955 class of communicants. Arturo Rivera, the fifth child from the left in the top row and his brother, Joseph, standing directly below Arturo, are the sons of immigrants Arturo and Adela Rivera. The family moved from Texas to Joliet in 1954 to work the Rousonelos Farm on Troy Road, and lived in a small house provided there. Seidl made it possible for the brothers to attend the parochial school. (Courtesy of the Joliet Historical Museum.)

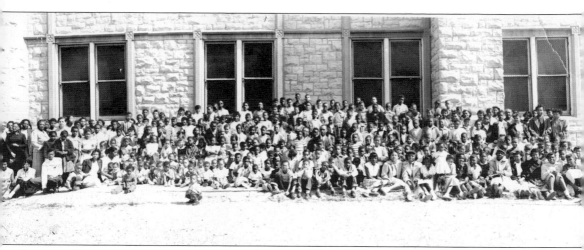

**JUNIOR MEMBERS OF SECOND BAPTIST CHURCH.** The children of Second Baptist Church enjoyed a warm summer day, as evidenced from this photograph taken outside the church at 156 South Joliet Street in this undated photograph. The Brown Book recorded the 1957 African American population in Will County at 14,000 based on government statistics, community surveys, and city directories. (Courtesy of Second Baptist Church.)

**JOLIET CENTRAL HIGH SCHOOL PROM.** "Moonlight Cotillion" was the theme of the Joliet Township High School Prom attended by Carolyn Evans and Tom King III on May 27, 1965. The Ray Gordon Orchestra provided the music as students danced in the school gym. (Courtesy of Tom and Carolyn King.)

**ST. FRANCIS ACADEMY ART CLASS.** The start of the 1968–1969 school year at St. Francis Academy (SFA) brought change to the school. A calendar full of curricular activities and newly organized clubs allowed girls more freedom. Art instructor Tita Recometa and her freshman art class rode the first fresh wave of self-expression extending beyond SFA's walls and into Joliet area activities. Pictured from left to right are Annette Thayer, Kay Gabrys, Debbie Loutos, Lynn Hrusosky, Marianne Wolf, Joyce Jasurda, Tita Recometa, and Pam Johansen. (Private collection.)

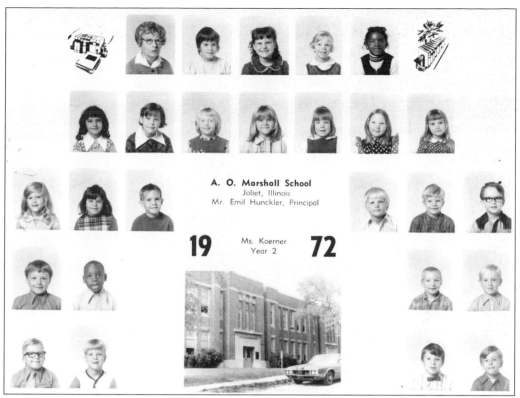

A. O. MARSHALL SCHOOL. Emil Hunckler was the principal in 1972 when Ms. Koerner's second graders were learning their multiplication tables. (Courtesy of Joseph Baines Jr.)

J. T. WEST PRESENTS *GUYS AND DOLLS.* On May 13, 14, and 15, 1971, the Fine Arts Department of Joliet Township High School West Campus presented Damon Runyon's *Guys and Dolls.* The production featured the school's A Cappella Choir under the direction of Roy E. Johnson. Brian Lewis performed in the lead role of Nathan Detroit, and Sky Masterson was played by Mark Bostjancic. (Private collection.)

JOLIET TOWNSHIP HIGH SCHOOLS — WEST CAMPUS
DR. ARTHUR L. BRUNING, Superintendent          JOHN G. VANKO, Principal

THE FINE ARTS DEPARTMENT
PETER LABELLA, Chairman

Presents

## GUYS and DOLLS

A Musical Fable of Broadway, based on a story and characters by
DAMON RUNYON

Music and Lyrics by FRANK LOESSER

Book by JO SWERLING and ABE BURROWS

Featuring
The Joliet Township High School — West Campus
A Cappella Choir

Directed by ROY E. JOHNSON

Thursday, Friday, and Saturday, May 13, 14 and 15, 1971

8:00 P. M. — West Campus Auditorium

### THE CAST
(In Order of Appearance)

| | | | |
|---|---|---|---|
| Nicely-Nicely Johnson | Ken Gutierrez | Lt. Brannigan | Bob Bristow |
| Benny Southstreet | Dave Lane | Nathan Detroit | Brian Lewis |
| Rusty Charlie | Steve Monroe | Angie the Ox | Mike Cinquegrani |
| Sarah Brown | Diane Johnson | Miss Adelaide | Julie Bolm |
| Mission Band | | Sky Masterson | Mark Bostjancic |
| Arvide Abernathy | John Nordmark | Voice of Joey Biltmore | Steve Monroe |
| Agatha | Chris Kaminskas | Mimi | Elaine Brown |
| Martha | Judy Schaeffer | General Matilda B. Cartwright | |
| Ruth | Claudia Beguin | | Deborah Papesh |
| Corporal Calvin | John Sather | Big Jule | Jeff Menzer |
| John | Dave Beguin | Night Club M. C. | John Hillman |
| Harry the Horse | Roger Copp | Waiter | Les Freeman |

JOLIET TOWNSHIP HIGH SCHOOL. The Joliet Township High School District was established in 1899. Construction began in 1900, and the school was dedicated on April 4, 1901. Local architect Frank Shaver Allen designed the castle-like Joliet limestone and Bedford stone–trimmed building located at 201 East Jefferson Street, listed in the National Register of Historic Places. (Courtesy of Jonas Astrauskas.)

JOLIET TOWNSHIP HIGH SCHOOL SIDE ENTRANCE 2006. At one time, a lit "Joliet Township High School" sign was hung across the stone building facing Jefferson Street in view of passengers on the Rock Island Railroad to identify the school. Local folklore is passengers riding the train through Joliet's Union Station thought they were seeing the Illinois State Penitentiary. (Courtesy of Jonas Astrauskas.)

# Five

# MEMBERS ONLY

The early part of the 20th century saw the urban population explode with an influx of immigrants. As much as its churches, politicians, and schools, Joliet's social clubs established an Americanization opportunity for immigrants. Social organizations were a way to interact with neighbors, support schools, and be actively involved in the politics of their neighborhoods. The clubs tied individuals into communities as the members worked together for a common good. These places provided entertainment and the opportunity to organize competitive sports, especially baseball and bowling.

There were many clubs in Joliet's history, although none has been as colorful or left its mark on the community as the Joliet Rivals Club, one of Illinois's largest independent organizations. Begun in 1907 by 17 men in Alex Meyers's Barber Shop at the corner of Ross and Hickory Streets, the club and its members have, for 99 years, exemplified the American tradition of good fellowship, hard work, and fair play to the finest degree.

Theiler's Park was the home of the first Rivals baseball team in 1907. Sundays were for families, and they would pack the grandstand each season to watch the great out-of-town teams go up against the Joliet Rivals club. Through rigorous training, many local men honed their baseball skills on that diamond and helped Rivals build one of the finest records in Illinois. Many of the players would go on to play in the major leagues. The original Rivals team disbanded after five successful years and baseball in Joliet would evolve in 1912 as a Joliet City league came into existence. After reorganization, Rivals was back on top, and in 1915, the team participated in intercity and semiprofessional competition. The Rivals drew 52,000 fans in 31 games during the 1916 season. The club would acquire Theiler's property in the 1920s, and change the name to Rivals Park. Renovations were made, and a new clubhouse with state-of-the-art bowling alleys would make Rivals the home for city league matches.

Rivals would move forward to organize softball, little league baseball, men and women's bowling leagues, little league bowlers, a basketball team, and a harmonizing quartet.

**WEST SIDE PLEASURE CLUB.** In the early years, the West Side Pleasure Club typified the many Joliet social organizations active in the community. This photograph hints at the hours of pleasure during evenings spent at club rooms and various social functions sponsored by such clubs. Others included Chaney Progressive Club, Club 66, Fraternal Order of Eagles, Irving Athletic Club, Moran A. C., Northwest Recreation Club, Veterans of Foreign Wars Cantigny Post 367, and American Legion Post 1080. (Courtesy of Rivals Club.)

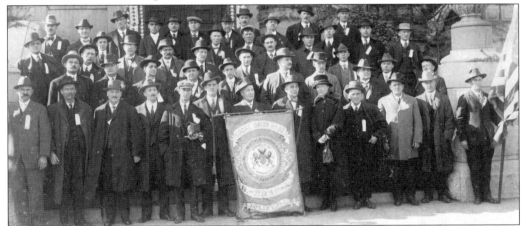

**FIRST STATE CONVENTION FOR BROTHERHOOD OF PAINTERS, DECORATORS, AND PAPERHANGERS OF AMERICA.** The brotherhood organized in 1887, affiliating with the AFL the same year. However, the union withdrew from the federation in 1891, and in 1894 split between western and eastern factions with headquarters in LaFayette, Indiana, and Baltimore, Maryland. The eastern faction adopted the name Brotherhood of Painters, Decorators and Paperhangers of America in 1899. The two factions merged under that name in 1900. In this photograph, one woman among all the men of Joliet Local No. 33 attended the first state conference. (Courtesy of the Joliet Area Historical Museum.)

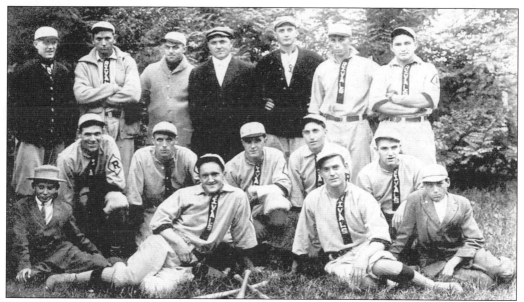

**JOLIET CITY LEAGUE CHAMPIONS OF 1914.** The Rivals ended the 1914 season as the Joliet City League Champions. Members of the team included, from left to right, (first row) unidentified, "Benny" Jackson (pitcher), John Wiles (right field), and unidentified; (second row) Louis Trost (third base), Elmer Schultz (first base), Harold Morie (center field), Stanley Kapella (left field), and Harold Bruce (utility infielder); (third row) Thomas Bothwick (captain, second base), Linc Bailey (pitcher), Monroe McOmber (shortstop), Fred Cooper (manager), Raymond Camp (catcher), Sam Bailey, and Martin "Shorty" Wiles (outfielders). (Courtesy of William Witczak.)

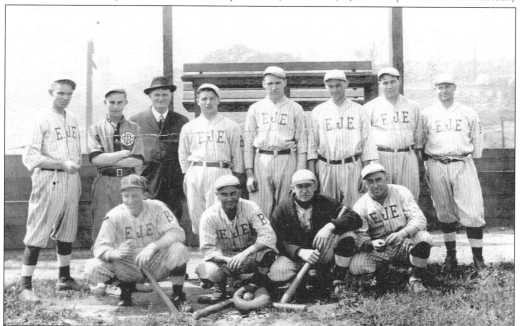

**ELGIN, JOLIET AND EASTERN RAILWAY BASEBALL TEAM.** Baseball has always been an important sport to Joliet, and industry as well as social clubs took it seriously in the early 1900s. Members of the 1925 Elgin, Joliet and Eastern Railway team are pictured here. (Courtesy of Thomas A. Kallai.)

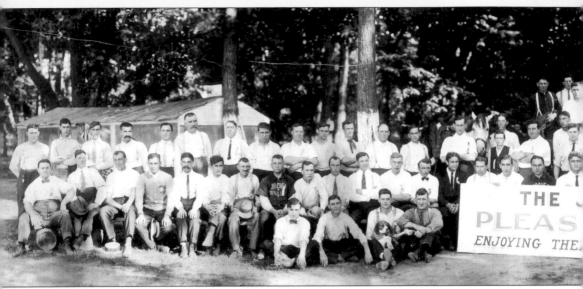

**JOLIET RIVALS PLEASURE CLUB FIFTH ANNUAL OUTING OF 1912.** According to club records, the annual outing was to be held at Rock Run Park with members transported in boats down the Illinois and Michigan Canal. It was noted during the second outing that the banks of the canal

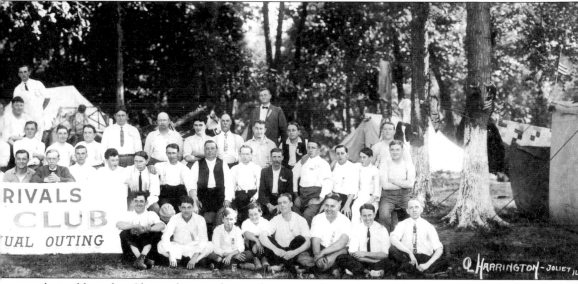

were being blasted at Channahon, making safe passage of members and their guests through the canal impossible. Clever thinking prevailed, and two coaches on the Rock Island railroad were chartered to ensure members would reach the park. (Courtesy of Rivals Club.)

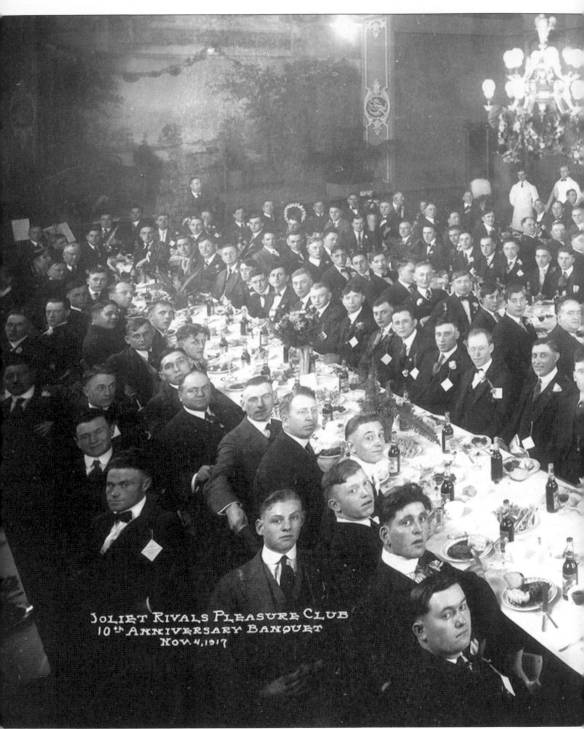

**JOLIET RIVALS PLEASURE CLUB 10TH ANNIVERSARY BANQUET.** On November 4, 1917, the Rivals Club held their anniversary banquet at Theiler's Park (now Rivals Park). More than half their members had gone to fight in World War I in 1917 and 1918, but the remaining brothers kept the spirit of the club alive. During these years, the club sponsored a junior baseball-team,

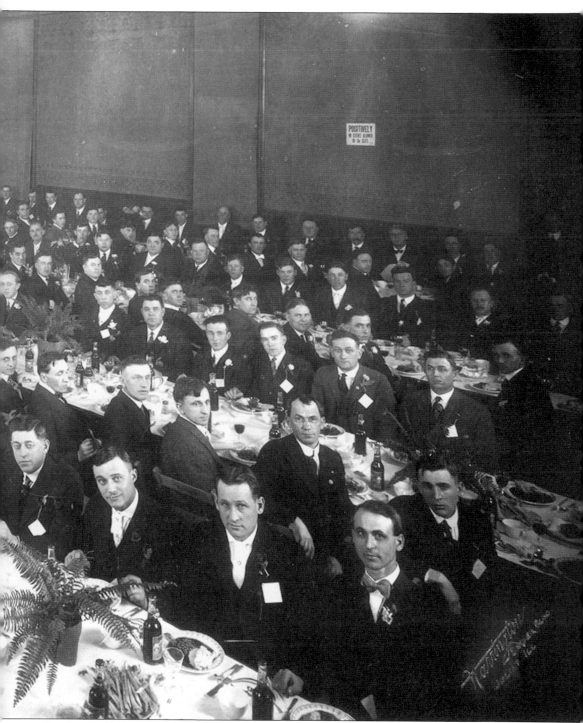

considered one of the fastest teams in northern Illinois. Besides speed, the juniors also had outfielder and hitter "Glen" White, one of the first female players in baseball history. White also added to the club's appeal as overflow crowds came out on Sundays to support the team and forget about the nation's concerns. (Courtesy of Rivals Club.)

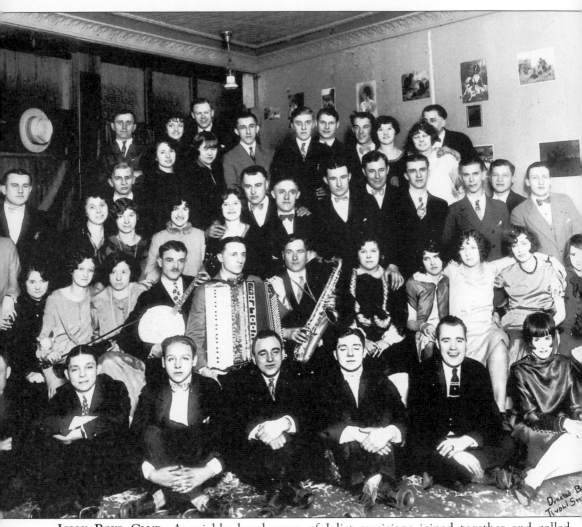

**JOLLY BOYS CLUB.** A neighborhood group of Joliet musicians joined together and called themselves the "Jolly Boys." Besides playing music, they also sponsored a winning baseball team. On New Year's Eve, December 31, 1926, members and guests celebrated at the Jolly Boys Club located on Ruby Street, just west of Broadway Street. From left to right are (first row) Frank Ferkel, Frank Ostir, John Umek, Joseph Zoran, Tony Kambic, Paul Lauric, Molly Zelko, and Mame Laken; (second row) Mary Russ, Theresa ?, Ann Juricic, Tony Deichman, Rudy Deichman, Joseph Perush, Mary Skul, Ann Zupancic, Betty Musich, Gen Lauric, Mame Lauric, and Katy Juricic; (third row) Kate (Umek) Skul, Rudy Skul, Mame Buchar, Mame Ivanich, Agnes Skul, Mary (Plut) Skul, Anthony Skul, Tony Russ, Frank Skul, Henry Bluth, Al Juricic, Frank "Fria" Juricic, Thomas Bucher, and John Lunka; (fourth row) Martin Juricic (down) Tony Sila (up), Agnes Buchar (down), Mary Zupancic (up), Josephine Bucher (down), Frank Zabkar, Louis Skul, Ed Juricic, Joseph Plut, Max Ivanich, ? Levandowski, unidentified, and Albert Skul (hiding) behind unidentified. (Private collection.)

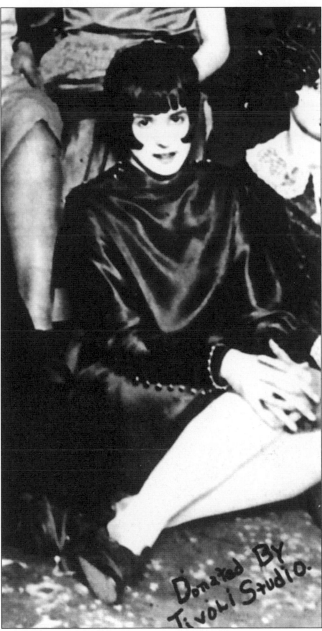

Donated BY
TivoLi STudio.

**MOLLY ZELKO.** Thirty-one years after this picture, Molly Zelko was reporter and co-owner of the *Joliet Spectator*, a weekly newspaper. Zelko would mysteriously disappear after leaving the tavern across the street from her office where she had ordered a cocktail and made two telephone calls from the bar's pay phone. On the morning of September 25, 1957, all that would be found of Molly were the shoes she had worn the night before. During her newspaper career she often told friends and family that when she feared for her life, she would kick-off her shoes and run. The following year, two true-crime magazines would feature Zelko as cover stories. Sheriff Joseph Trizna and 5,000 residents signed a petition requesting FBI help, but J. Edgar Hoover, FBI director at the time, personally declined the case. Zelko was declared legally dead in 1964, seven years after her disappearance. Her body has never been found. (Private collection.)

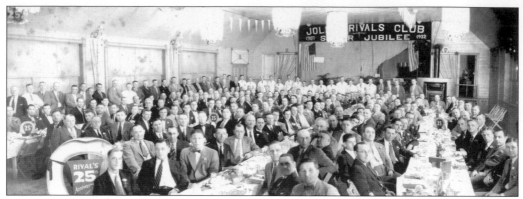

**JOLIET RIVALS CELEBRATE SILVER JUBILEE 1932.** According to club records, the Rivals celebrated their silver jubilee September 19, 1932, with a banquet in their dance hall. The toastmaster was Timothy Pell. Some 250 members and guests were entertained at the banquet by vaudevillian acts, an orchestra, and a theatrical play depicting the birth of the club. (Courtesy of Rivals Club.)

**JOLIET BOTANICAL CLUB.** Members of the Joliet Botanical Club smile for the photographer at this gathering on Valentine's Day 1931. The group enjoyed outings held at Pilcher Park's Italian Renaissance greenhouse built in the early 1900s. (Courtesy of the Joliet Area Historical Museum.)

**JOLIET RIVALS CLUB LEAGUE CHAMPIONS 1938–1939.** These proud bowlers, all in shirts and ties, except for one, won the 1938–1939 league championship at Rivals Park. Bowling was always one of the most important activities at the Joliet Rivals Club. In 1938, the club installed 10 new additional bowling lanes in a new, modern building next to its existing clubhouse. But a fire would destroy all of it in 1947. Four hundred bowlers lost their equipment in the locker room facilities adjacent to the alleys. (Courtesy of Joliet Rivals Club.)

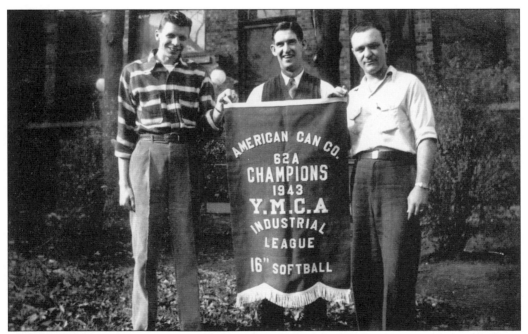

**INDUSTRIAL LEAGUE 16-INCH SOFTBALL.** Identified here, ? Barnes, Jack Madden, and "Iggy" Kezerle were members of the American Can Company 62A 16-inch softball team. In 1943, the team won the YMCA Industrial League title. (Courtesy of Kathryn Lorenc.)

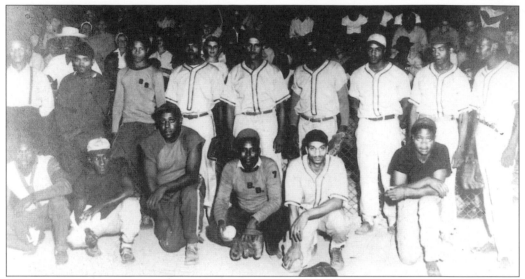

**THE BROWN BOMBERS.** Joliet's powerhouse Brown Bombers were, from left to right, (first row) J. W. Holloway, Ernie Milligan-Warren, Beverly Burton, Warren "Babe" Mitchell, Mose Williams Jr., and Audrey Green; (second row) Mose Williams Sr., Donald Brown, Charles Martin, Edgar Martin, Charles Meade, Narvis Sims, Floyd Boysaw, Laverne Smith, and J. C. Mitchell. (Courtesy of the Joliet Area Historical Museum.)

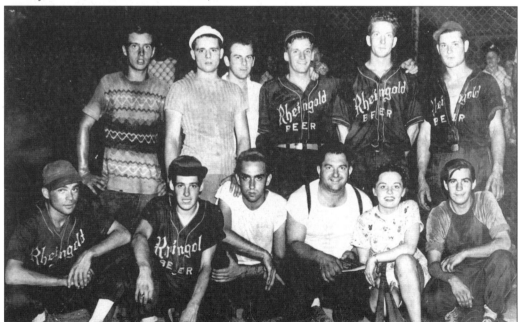

**RHEINGOLD BEER BALL TEAM.** On August 6, 1947, the team participated in Donkey Baseball at Rivals Park. Every team member except the pitcher and catcher played the game while on live donkeys, with names such as Mae West, Lana Turner, Dorothy Lamour, Fuzzy Wuzzy, Joe Palooka, and Blondie. The Rivals baseball diamond was located at the corner of Broadway and Russell Streets. Pictured here, from left to right, are (first row) Leo Kren, Bob Welz, Dan Meznarsic, Bookie Bucavich, Colette Stuckel, and Butch Welz; (second row) Pott's O'Brien, Wilfred Stukel, Eddie Vicich, Bob Vertin, Benny Papesh, and Eddie Strle. (Courtesy of Peter Papesh.)

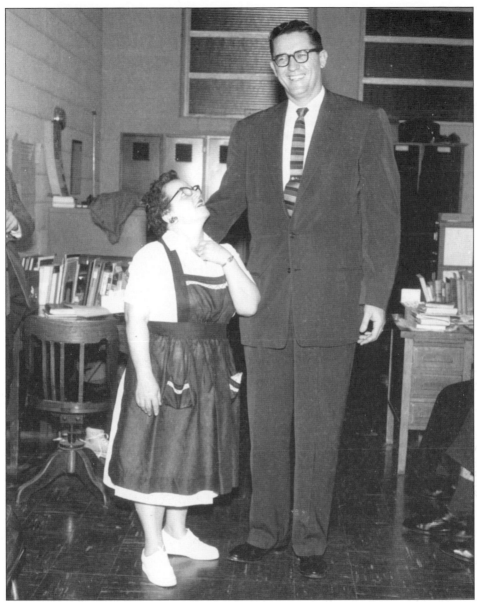

**GEORGE MIKAN.** This undated photograph of Ann Galvan (left) with six-foot-ten-inch-tall basketball superstar George Mikan was taken at a Joliet Catholic High School banquet. Born on June 18, 1924, in Joliet, Mikan attended Joliet Catholic High School (1937–1938) before revolutionizing basketball while a player at DePaul University. Mikan scored 1,870 points and was a three-time All American (1944, 1945, and 1946). Mikan won his first professional championship with the Chicago American Gears of the National Basketball League in 1947 and would go on to capture six additional professional titles—five with the Minneapolis Lakers, becoming the first dominant big man in professional basketball. Mikan led the National Basketball Association in scoring six times between 1946 and 1952, led the league in rebounding in 1953, and scored 11,764 points in nine professional seasons. The Associated Press voted George Mikan the "Greatest Player in the First Half-Century." Mikan died on June 2, 2005. (Courtesy of St. Mary Nativity Church.)

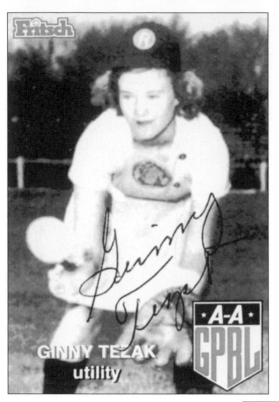

**VIRGINIA "GINNY" TEZAK.** Virginia Tezak Papesh of Joliet played for Wisconsin's Racine Belles in the All American Girls Professional Baseball League in 1948. Papesh, first-base and utility infielder, originally started out with Illinois's Springfield Sallies and was reassigned to the Belles. The female league began in 1943, when World War II placed the future of men's major-league teams in jeopardy. Today Tezak's uniform is on display at the National Baseball Hall of Fame in Cooperstown, New York. (Courtesy of Virginia Tezak Papesh.)

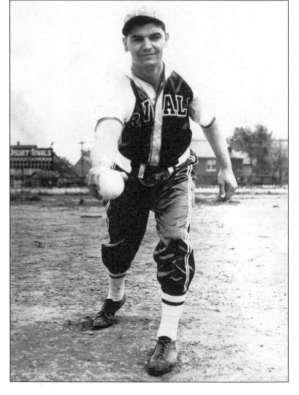

**EDWARD "ZOMBIE" KUBINSKI.** Edward "Zombie" Kubinski was a veteran twirler by the age of 29. By 1941, the five-foot-10-inch, 190-pound pitcher had been playing in and out of Rivals for eight years. Kubinski could also play in the outfield and was a heavy hitter. This 1940 photograph shows Kubinski with the scoreboard at the south end of Rivals Park along Russell Street. (Courtesy of Rivals Club.)

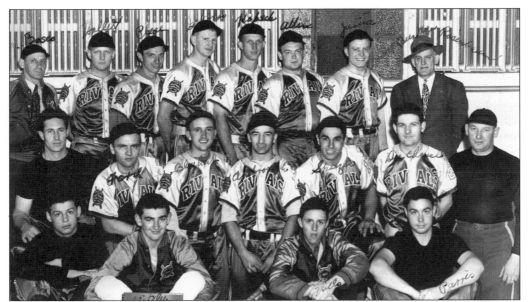

**JOLIET RIVALS SOFTBALL 1945.** Joliet's first lighted baseball diamond was installed at Rivals Park in 1934, and Rivals became home to one of the Midwest's most famous fast-pitching softball teams until the late 1950s. Fred Boseo piloted the 1944, 1945, and 1946 teams. Coach Boseo and Frank Rosenbaum, the team's business manager, are shown here with the 1945 team. Note the uniform sleeve patch signifying "Champion 1941 Joliet Rivals Illinois major softball league." (Courtesy of Rivals Club.)

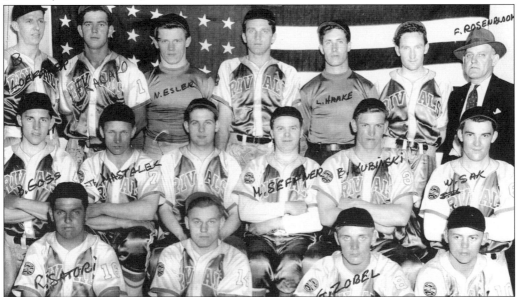

**SOFTBALL CHAMPIONS.** Louis "Iron Man" Haake (top row, third from right), broke all existing pitching records at Rivals in 1948 by winning 30 games. Haake joined the team in 1937, and for the next 11 years, his strength and speed made him the "most effective of any hurler." His all-time record of 140 victories with only 32 defeats was considered one of the best records accumulated by a local pitcher in 1948. Haake is shown with his Rivals teammates in this *c.* 1948 photograph. (Courtesy of Rivals Club.)

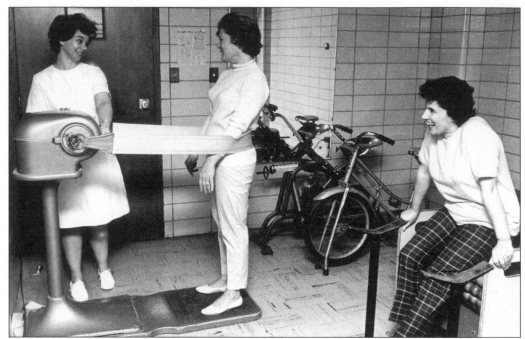

**JOLIET YMCA WOMEN'S HEALTH CLUB.** Darlene Cosgrove (left), assistant manager of the club, gives Mrs. Robert Musser and Mrs. Robert Schultz instructions on using the exercise machines at the Joliet YMCA in 1960. (Courtesy of LaVerle Mackey.)

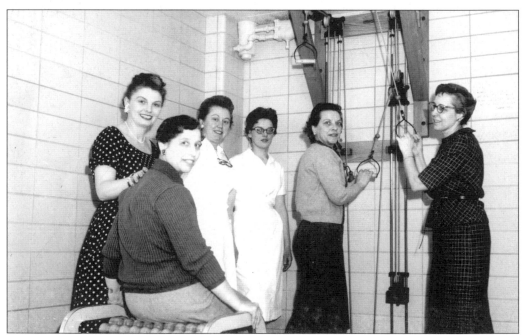

**TOUR THE YMCA.** From left to right, Nora Mae Biggs, Helen Ruttle, Cornelia "Corny" Kern, unidentified, Lois Carlin, and Erma Agazzi Chuk tour the women's health club in 1961. (Courtesy of LaVerle Mackey.)

**LEARN TO SWIM PROGRAM AT LOCAL YMCA.** Donald Angus instructs Joydaha Campers at the YMCA pool in the "Learn to Swim" program in the early 1960s. (Courtesy of LaVerle Mackey.)

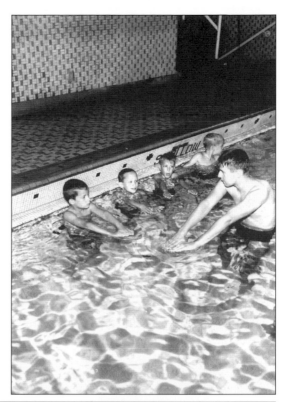

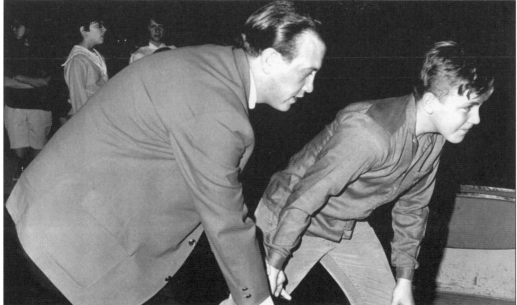

**PRO-BOWLER JIM STEFANICH.** During his senior year at Joliet Catholic High, Jim Stefanich played varsity golf, but by 1965, he had joined the Pro Bowlers Association. At the age of 22, Stefanich won the first of seven ABC National titles. This right-handed bowler claimed 14 titles during a 24-year PBA touring career. PBA Player of the Year in 1968, Stefanich was inducted into the PBA Hall of Fame in 1980 and the ABC Hall of Fame in 1983. (Courtesy of Rivals Club.)

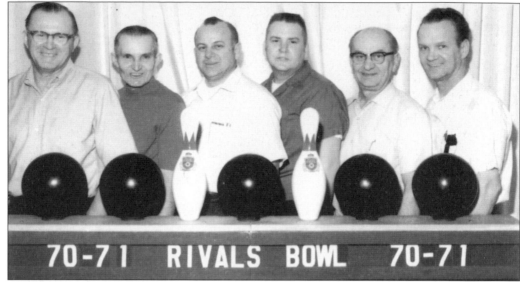

**NORTHWEST RECREATION CLUB BOWLERS 1970–1971.** In January 1948, Joliet Rivals placed a new cornerstone, according to club records, and a more modern air-conditioned clubhouse would be constructed. New Brunswick Lanes featuring automatic pin spotters and range finders drew bowlers from all over Joliet. Leagues participating in weekly bowling were Illinois Bell Telephone, Order of Eagles, American Steel and Wire, Chaney Progressive Club, Speedboys Club, Globe Oil and Refining, Skedels Tavern, and Northwest Recreation. (Courtesy of Rivals Club.)

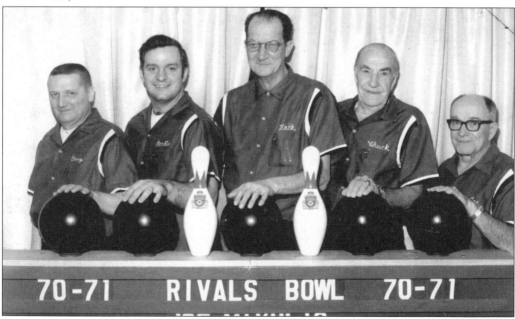

**RIVALS BOWL 1970–1971.** Pictured in this 1970–1971 Rivals Bowling team photograph are, from left to right, Anthony Mihelich, Gordan Beutel, Al "Hank" Papesh, Chuck ?, and Joseph Mikulic (captain). Rivals bowlers also organized the Rivals Park Little League Bowlers for boys ranging in age from nine to 16 years. During the 1950s and 1960s, Saturday mornings had 60 junior bowlers on the bowling lanes. (Courtesy of Rivals Club.)

**ASSOCIATED CLUBS OF GREATER JOLIET.** Arthur and Frances (Jacksa) Schultz are the couple on the left pictured at the Associated Clubs Couples Nite at Rivals Club on November 11, 1985. The other couples shown include Joseph and Barbara Kociuba, Ernest and ? Vercellina, and Lois and Steven Pristas. Arthur Schultz was elected mayor of Joliet in 1991 and has served the citizens of Joliet through a major period of redevelopment and growth. (Courtesy of Allen Mihelich.)

**JOLIET KOLO DANCERS AND CROATIAN INTERNATIONAL BASKETBALL TEAM.** The Joliet Kolo Dancers entertained the spectators with artful folk dancing at halftime during the exhibition game between the Croatian Basketball Club of Split, Croatia, and the College of Saint Francis team of Joliet on November 4, 1994, at the college recreation center. (Courtesy of Matilda Wilhelm.)

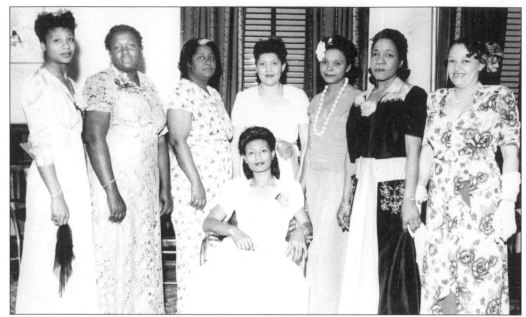

THE ASSEMBLY SOCIAL KLUB, INCORPORATED. Under the sponsor ship of John M. Boyden, the Assembly Social Klub, Incorporated, was organized on February 10, 1946, for the purpose of promoting social activities among its members and friends. Members pictured together are, from left to right, Margaret O'Large, ? O'Large, ? Sullivian, ? Williams, Lillie Young-Smith, Ann Sneed, Levinia Smith, and Mallie Hogue (seated). (Courtesy of Walter Whitehead.)

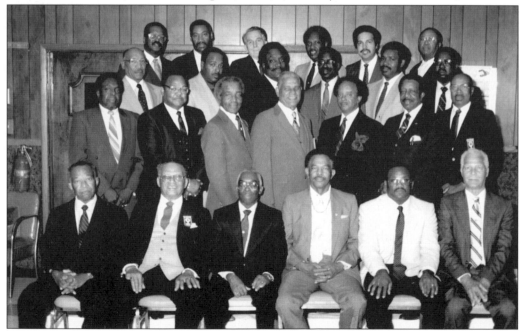

THE BEACON SOCIAL CLUB OF JOLIET. John M. Boyden served as temporary chairman of the Beacon Club after its founding in December 1954. The stated purpose of the club is to promote social interaction among the members and friends. Today James Shaw is the acting president. (Courtesy of Beacon Social Club.)

# Six

# STEPPING OUT

Steel and stone shaped Joliet, but how its people entertained themselves defined the city's personality. Civic activities and national events were all causes for celebration. The neighborhoods of the city reverberated with the sights and sounds of stage and screen presentations at the palatial Rialto Theatre, summer dances to the music of Wayne King, Art Castle, or Sammy Berk's band in the pavilion at Dellwood Park, VJ Day festivities spilling from Cass to Jefferson Streets on the night of August 14, 1945, a fountain chocolate coke at Stilman's Pharmacy, the roar of aircraft during the Joliet Air Shows held at Municipal Airport, *Herald-News*-sponsored cooking classes held at the Rialto Square, ice-cream sundaes at Weber's Dairy, summer carnivals in Rivals Park, a grilled cheese and a Green River at the counter of Kresge's, roller skating at Mikan's on North Broadway, hamburgers and root beer at Silver Frost Drive-In on Cass Street, Cooper's Café for sea food and creole, a new hairstyle at Marieze Beauty Shop, fashion shows sponsored by the Busy Bee Club, the Rainbow Society Tea and All Male Style Review, shopping at Al Baskin, breakfast at Ford Hopkins Drugs on Chicago Street, ice-cream sodas at Pelico's Ice Cream Store on the corner of Cass and Chicago Streets, the Steel Works Club at Collins and Irving Streets, the Crusoe Orchestra on stage at the Rialto, shopping for shoes at Lewis Brothers, the children's room at the library, the festive opening of the first McDonald's in town in December 1956, Michigan Beach for a swim, the Sunday night teen socials held at Joliet Catholic High, movies at the Mode Theater, church picnics on Sunday afternoons at St. Joseph's Park on Raynor Avenue, summer "Wild Goose" concerts with Larry Lujack at Inwood, fireworks on the Fourth of July, ice skating at Inwood on Friday nights, Liberace on stage at the Rialto, a clip from the barber at Banana Joe's, miniature golf at Haunted Trails, dancing to Don Lippovic at the Croatian Culture Club, and the Joliet Drama Guild on stage at Bicentennial Park Theater.

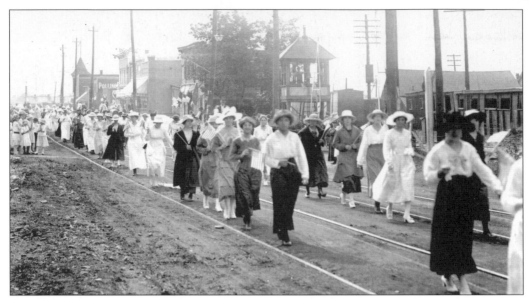

**LADIES ON PARADE.** These flag-waving suffragettes were on the move to get the vote for women in a parade during the early part of Joliet's history. (Courtesy of the Joliet Area Historical Museum.)

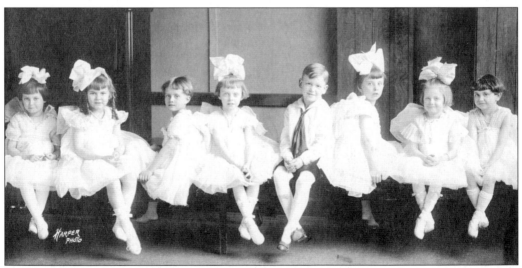

**CASTLE SCHOOL OF DANCE.** Mel Pohl is the young boy in this dance class of pretty bow-haired little girls from the Castle School of Dancing and Music. Minnie Webb Castle, widow of Hubert Castle, instructed classes at the studio located at 225 East Jefferson Street. (Courtesy of the Joliet Area Historical Museum.)

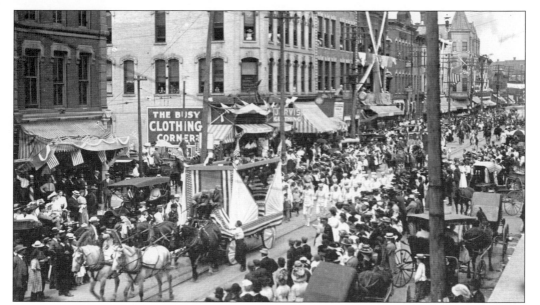

ELKS CIRCUS PARADE. Every popular event was celebrated by a parade in the early days of Joliet. Certainly the circus coming to town was a reason to celebrate. This Elks circus parade on August 17, 1909, moves south down Chicago Street from Van Buren Street. (Courtesy of the Joliet Area Historical Museum.)

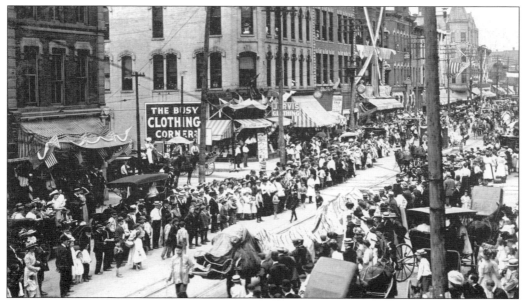

CHINESE DRAGON. The Elks are "a distinctively American, intensely patriotic, family-oriented organization." In this photograph of the 1909 parade, a Chinese dragon delights the crowd. (Courtesy of the Joliet Area Historical Museum.)

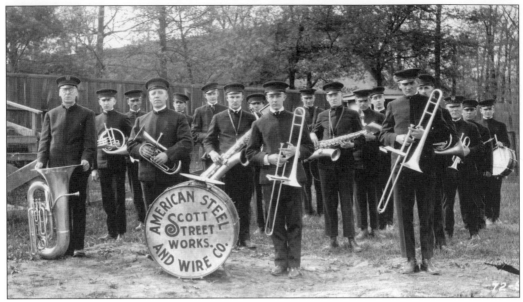

**SCOTT STREET WORKS BAND.** Members of the American Steel and Wire Company Scott Street Works Band line up in this 1920 photograph. The band played on hundreds of noteworthy occasions throughout the early history of Joliet. Local newspaper clippings report the band's participation in events such as the 1902 procession and dedication ceremony of Holy Cross Church, the 1907 arrival of Archbishop Quigley of Chicago at the Rock Island Depot, and the historic 1908 funeral of Italian leader, Giovanni Tipatti. (Joliet Area Historical Museum.)

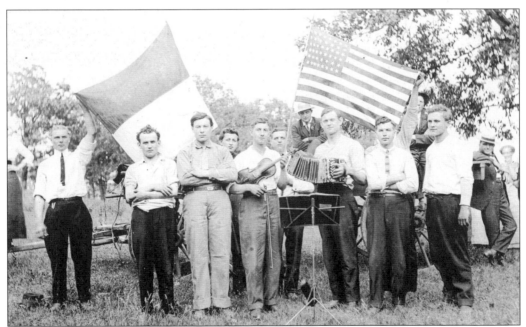

**POLISH COMMUNITY PICNIC.** This photograph suggests memories of the parish picnics held by Holy Cross Church. The park is filled with music, native song, and tasty ethnic food. (Courtesy of the Joliet Area Historical Museum.)

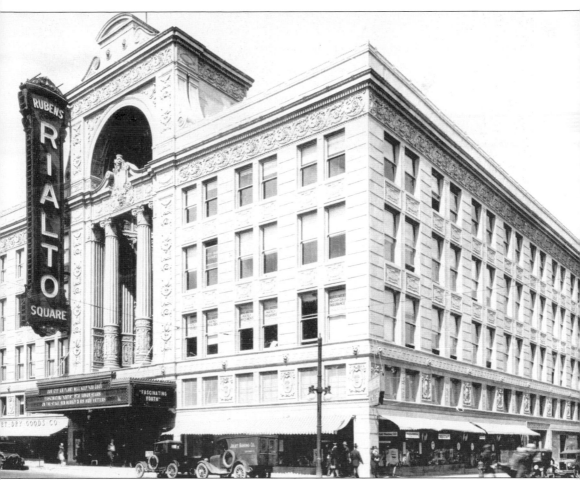

**RUBENS RIALTO SQUARE.** The Rubens Rialto Square designed by the Chicago architectural firm of Rapp and Rapp has been considered one of the most beautiful theaters in the nation since its grand opening to officials on May 23, 1926. It took the Kaiser-Ducett construction company two years to build this jewel of Joliet at a cost of more than $1 million. The vaudevillian stage and movie palace was the focus of "Greater Joliet Week" celebrations hosted by civic leaders and downtown businessmen. Fireworks, street parades, and band concerts entertained thousands of citizens and visitors from surrounding towns who crowded the downtown district during the occasion. (Courtesy of the Joliet Area Historical Museum.)

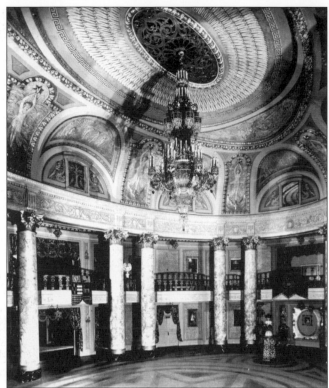

**GRAND LOBBY OF THE RIALTO.** The main rotunda contains 18 Corinthian marble columns that reach to the dome, which features images of the Goddess of the Eastern Star. The Duchess crystal chandelier is 20 feet long with 250 lights. Dorothy Mavrich, president of the Rialto Square Arts Association—now the Cultural Arts Center of the Joliet area—initiated the campaign responsible for the restoration. Begun in April 1980, it turned the former palace into the current performing-arts center. (Courtesy of the Joliet Area Historical Museum.)

**BARTON GRANDE THEATRE PIPE ORGAN.** Joliet audiences recall watching silent movies and vaudevillian stage shows accompanied by the magical music from the Rialto Square's Barton Grande Theatre Pipe Organ. In 1981, the organ was restored by the Joliet Area Theatre Organ Enthusiasts. (Private collection.)

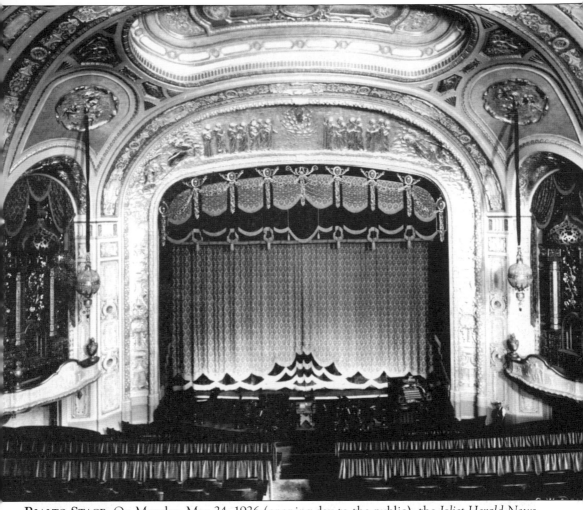

**RIALTO STAGE.** On Monday, May 24, 1926 (opening day to the public), the *Joliet Herald News* reported that Bailey F. Alert conducted the Rialto Concert and Novelty Orchestra with Leo Terry at the Barton Grand Theatre Pipe Organ. *The Evolution of Joliet* was presented on stage with a cast of 30 entertaining artists, and *Mlle. Modiste* with Corrine Griffith and Norman Kerry was featured on the movie screen. Performances were continuous from 1:00 p.m. until 11:00 p.m. daily. Admission for adults was 50¢, children were 25¢. This view shows the proscenium arch with grand drape and ornate balconies on the sides of the Rialto stage. The man wearing the straw hat right of the organ chamber was "Frenchy" Lewis—property man for the Rialto. (Courtesy of the Joliet Area Historical Museum.)

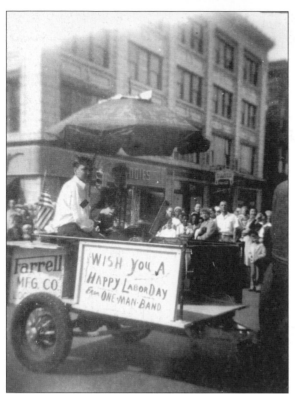

**TROPPE ON PARADE.** The "One-Man Band," Frederick Troppe, rides along the parade route in downtown Joliet as the community celebrates Labor Day in 1936. (Private collection.)

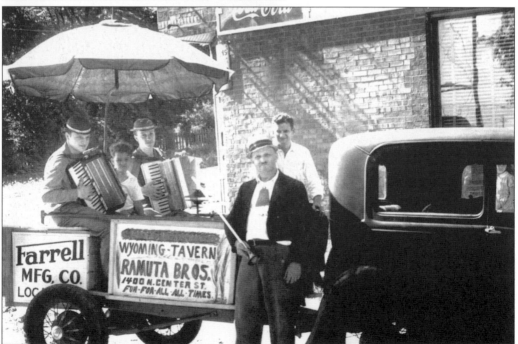

**STREET ENTERTAINERS.** Troppe is pictured along with his sons playing their accordions. Alfred is on the far left, and Herman is in the center. The umbrella was rigged to spout water on the unsuspecting crowd at the end of the performance. (Private collection.)

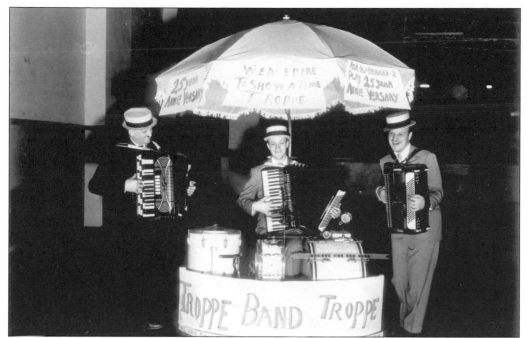

**ALL IN THE FAMILY.** The Troppe Band of Joliet had a musical history. Alfred, pictured on the right, earned his Doctorate in music, and went on to perform with Frank Sinatra, Jackie Gleason, and opera star Risë Stevens. Herman, under the umbrella, appeared as a guest performer with the Chicago, Boston, and Minnesota Symphony Orchestras. (Private collection.)

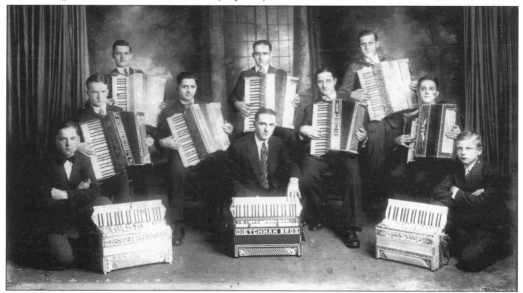

**RUDY DEICHMAN.** Rudy Deichman, pictured here, front row center behind his accordion, taught this 1925 Joliet accordion class. Deichman was born on North Broadway Street in 1901 and continued to live in the same house until his death at age 94. Deichman, along with his brother Tony and friend Joseph Perush, recorded for Victor and Columbia records between 1927 and 1945. The Deichman Orchestra could be heard on Sunday afternoons on local radio station WJOL. (Private collection.)

THE WORLD'S TALLEST MAN VISITS JOLIET. Robert P. Waldow, at the height of eight feet and 11.1 inches, was the tallest person in history as recorded in the Guinness Book of Records. Waldow traveled as a goodwill ambassador for the International Shoe Company, and on October 11, 1936, made a stop at Joliet's Union Station. He is shown here shaking hands with Capt. Joseph R. Trinza. (Courtesy of the Joliet Historical Museum.)

THE DOODLERS PERFORM AT A SUMMER PICNIC. In the 1940s the Doodlers played music throughout the Joliet area. In this 1948 picture taken at a summer picnic, from left to right, Hunz Kriegher, drummer, uses real turkey legs for drum sticks; Midge Troppe, bass player, plays a can/string/broom handle; Michael Hrebel plays accordion; and Matt Micetich is the man wearing the white hat. (Courtesy of Joseph Govednik).

**LABOR DAY PARADE.** Joliet has always enjoyed a parade. This 1941 Labor Day parade was no exception. Visible in this close-up are the women of the Bookbinders Local 174 of the American Federation of Labor as they march south on Chicago and Cass Streets. Parked behind them are the Schiek Motor Express truck and the Star Paint Service delivery truck. The Kaybee Credit Clothiers sign is visible above and to the left. (Courtesy of the Joliet Area Historical Museum.)

**RADIO DAYS.** During World War II, Rudy Deichman, with accordion, played a weekly radio broadcast from the tavern at 1101 North Hickory Street. In this photograph, Tony Deichman (Rudy's brother) is on the far left, Fran Turk is the soldier in the tipped hat, William Mandac is the sailor behind Deichman, ? Stronghouse is the sailor next to the accordion, and William Bly is behind Deichman. The others are unidentified. (Private collection.)

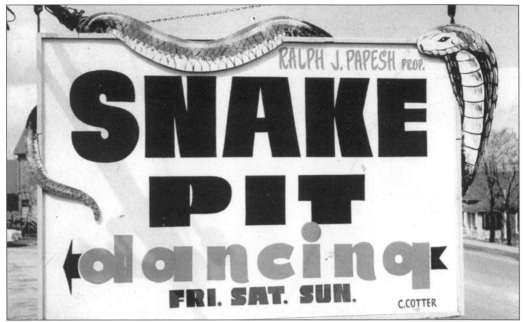

**SNAKE PIT BILLBOARD.** The Snake Pit Tavern, located on Alternate Route 66 was "Will County's Largest Nite Club" in 1953. Weekend performances included polka and popular dance music. These photographs reflect some of the regular patrons along with the whimsical personalities that entertained them. (Private collection.)

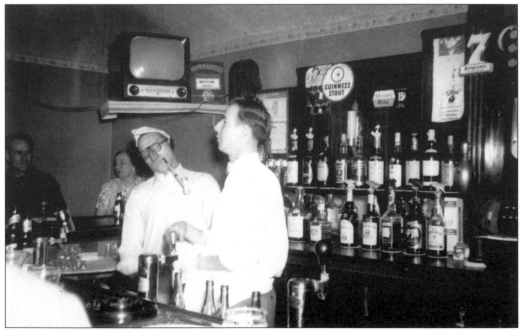

**INSIDE THE SNAKE PIT.** Bartenders are part of the act for neighborhood customs as Peter Papesh, left, entertains patrons while Robert Podobnik listens to a customer's cocktail order. (Private collection.)

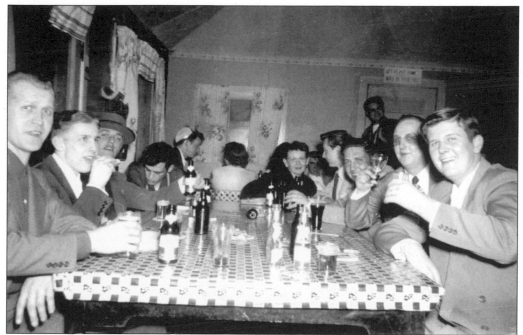

**PATRONS.** The neighborhood bar was the place for camaraderie. In the early 1950s, places such as the Snake Pit provided entertainment and a social venue for neighbors. (Private collection.)

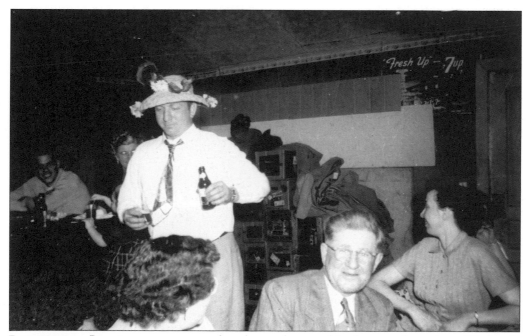

**BARTENDERS.** Proprietors were more than bartenders, as this photograph suggests. Weekends were always a party with live bands, dancing, and comedic acts. (Private collection.)

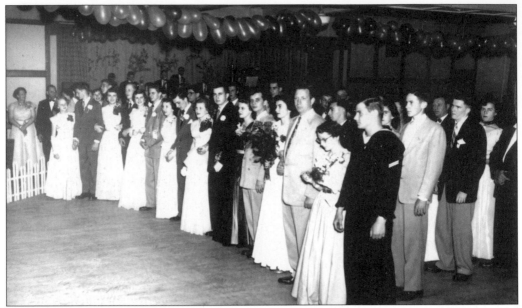

**SODALITY DANCES.** The Young Ladies Sodality of St. Mary Nativity held formal dances in the 1940s and 1950s. Pictured here in the decorated parish hall in 1950, couples were members of both St. Mary's and the neighboring parish, St. Anne's. (Private collection.)

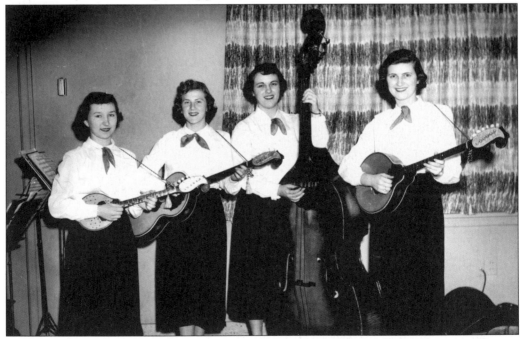

**JOLIET ROZMARIN TAMBURITZA.** This 1950 photograph is of the Joliet Rozmarin Tamburitza. Members included, from left to right, Barbara Putrich, Cecilia Gečan, Lillian Stiglich, and Rose Stiglich. The girls started performing together while attending Joliet Township High School and had their music played on the Sunday afternoon Croatian Radio Program hosted by local radio personality, Al Pohler. Rozmarin traveled in Iowa and Illinois performing at popular Croatian venues. (Private collection.)

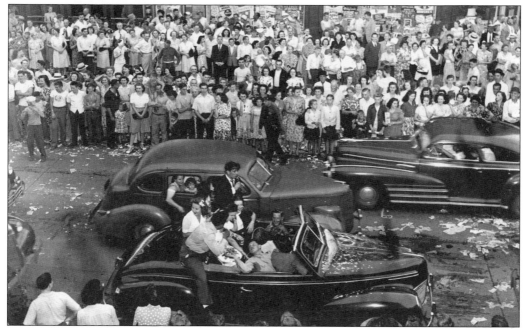

**BRING THE BOYS HOME.** Driver Robert Tezak put the convertible top down and piled family and friends into the car to join the crowds lined along Chicago Street for Joliet's VJ Day parade celebrating an end of World War II. Mary Ann Tezak, Theresa Bergstrom, Lillian Duras (flower in hair), and ? Baudek celebrated with an unidentified soldier and men from the neighborhood. (Courtesy of the Joliet Area Historical Museum.)

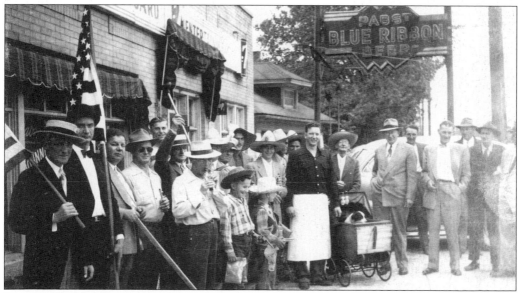

**PARADES DOWN BROADWAY.** Long before Joliet became the bustling city of today, parades starting at 1301 North Broadway were a common occurrence. Included in this 1950s picture, Ralph Papesh, John Gerl, Butch Wellz, Joseph Muren, Peter "Benny" Papesh, Walter "Shep" Shepich, Leo "Tiger" Kren, Michael Rebats, and Snaky, the dog in the baby buggy, prepare to stop traffic. (Courtesy of Peter Papesh.)

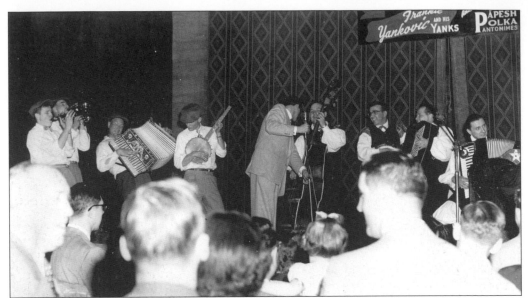

**PAPESH POLKA PANTOMIMES.** The Papesh Polka Pantomimes, Joliet performers, were booked as a warm-up band for "America's Polka King"—Frankie Yankovic and his Yanks at Sokol Hall in 1954. (Private collection.)

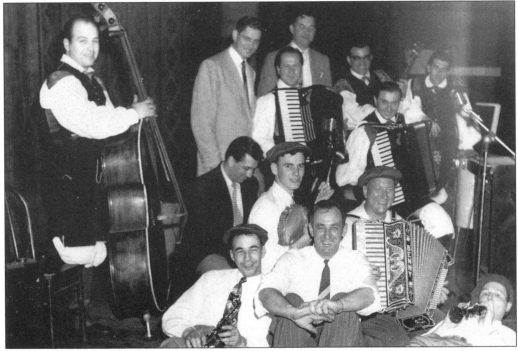

**ONSTAGE WITH YANKOVIC AND HIS YANKS.** The Pantomimes had such a large audience that Yankovic welcomed the Joliet musicians to join him and his band on stage and play a few tunes with them. From left to right are (first row) Robert "Ponky" Podobnik, Tony Kochevar, and Joseph "Chach" Wolf; (second row) Ralph Faucher, Anthony Wolf, and Peter "Benny" Papesh; (third row) Al Leslie, Ed Blatnik (Chicago radio DJ), Joseph Sekarde, John Korosa, Edward Teener, Frank Yankovic, and Emmet Morrel. (Private collection.)

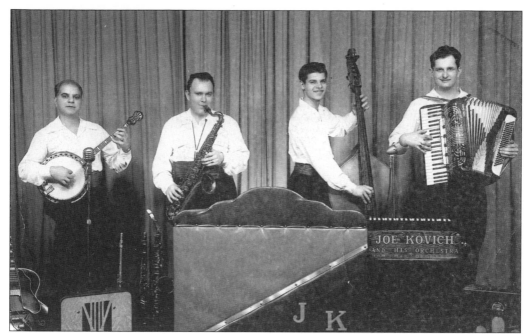

JOE KOVICH AND HIS ORCHESTRA. Joseph Kovich and his Orchestra played all the popular songs around town during the 1950s. Ready for the next request, from left to right, Joseph Kovich, Stanley Mozina, Daniel ?, and Leo ? made a fine quartet dressed in their white shirts, tuxedo trousers, and colorful sashes. (Private collection.)

"J" HOT BOXES. De Caldwell, Arthur Biras, and Harley Dowell were the musical trio known as the "J" Hot Boxes in 1951. (Courtesy of the Joliet Area Historical Museum.)

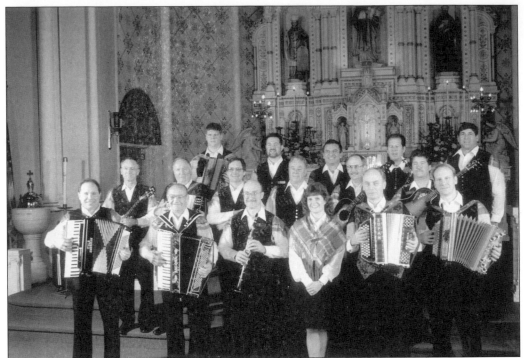

**POLKA MASS-TERS.** The Polka Mass-ters began playing lively polka music to church congregations throughout Joliet and Will County in 1987. Pictured in front of the altar of St. Joseph's Catholic Church in 1998, the band of volunteers raises money through a special collection during mass for hospice. Since their beginning, more than $400,000 has been raised for the Joliet Area Community Hospice. (Private collection.)

**EASTER SEALS TELETHON.** Argosy's Empress Casino hosts the weeklong telethon for Will-Grundy Counties Easter Seals Rehabilitation Center. The casino opened in Joliet in 1992, and annually attracts 2.4 million visitors. Joliet's Polka Mass-ters are shown performing at the casino for the broadcast in 2005. (Private collection.)

**HARRAH'S CASINO.** Located in the city center at 151 North Joliet Street, Harrah's opened in 1993 and provides more than 1,700 jobs in the area. Joliet citizens benefited, as tax money generated by the casino has funded the Joliet Area Historical Museum, a west side branch of the Joliet Public Library, a decrease in monthly sewer and water bills, and a rebate on senior utility bills. (Courtesy of Jonas Astrauskas.)

**SILVER CROSS FIELD.** Silver Cross Field opened on the east side of downtown Joliet in 2002 and is home to the Joliet Jackhammers. This 6,500-seat stadium offers free parking, free programs, and a covered picnic area for fans. "Hang to Win" is an entertaining game gimmick as one lucky Velcro-suited fan attempts to hang from a Velcro wall for seven innings and catch a home run ball (glove provided) to win a brand new car. (Courtesy of Jonas Astrauskas.)

# ACKNOWLEDGMENTS

Growing up, I never realized how distinctive the culture of Joliet was with its ethnic neighborhoods until I went to college and began to travel Illinois and our country. From the pride I developed for my hometown emerged a willingness to share the story of this great city.

The first tale I remember being told was of my paternal grandfather and his decision at the age of 16 not to return with his father to their native village, Plešce, Croatia. He wanted to stay in Joliet where he could work and always own a proper pair of shoes. Likewise, my maternal grandfather arrived in Joliet as a young boy, having left the village of Mrkopalj, Croatia, with his parents for a better life. I remember both of them as hard-working, determined men who never complained. At their side, I was exposed to life values: the importance of family, the neighborhood parish and its community, education, and a work ethic I now have. This book would not be possible without those early impressions and the efforts made by my grandparents.

I owe a great deal to my parents, Joseph and Cecilia, who have provided immeasurable help to me with this project and a lifetime of encouragement. The great majority of photographs shown here appear through the courtesy of them and their lifelong family of friends, a generation of people who are natural storytellers.

I am extremely grateful to the many people who, in numerous ways, assisted me with this project, first among them is John Pearson, publisher at Arcadia, who encouraged me to write the book, and my editor, Ann Marie Lonsdale. This undertaking would not have been possible without the cooperation of Joliet mayor Arthur Schultz and councilman Timothy M. Brophy; Susan English, Walter Keener Jr. (curator), and volunteers Richard and Linda Carlson of the Joliet Area Historical Museum; Jonita Ruth, Slovenian Women's Union Heritage Museum and Fraternal Organization; Joliet Rivals Club; Edward Ancel; Fr. Christopher Groh; Lisa Luckritz; Lisa Mammosser; Larry Rossi with Metra; Joseph Baines Jr.; Betty Johnson; Landon Risteen; Donald Baskin; Charles Staples; Joyce Dunn; Marion Gold; Whitney Scott; and my husband, Jonas.